Published in 2019
by Truther Press
First Edition (of Many)
© Sean Preston & Scott Manley Hadley

This is a work of the authors' imagination. Names, characters, businesses, places, events, locales, even the bits about that lying son of a bitch Jerry Seinfeld working for the devil, and incidents are either the products of their imagination or used in a fictitious manner. Any resemblance to actual persons, living or dead, or actual events is purely coincidental.

This book is sold subject to the condition that it shall not, by way of trade or otherwise, be lent, re-sold, hired out or otherwise circulated without the publisher's prior consent in any form of binding or cover other than that in which it is published and without a similar condition including this condition being imposed on the subsequent purchaser.

Scott Manley Hadley's photographs by Paul D. Rowland.

BECAUSE EARTH IS FLAT

A FLAT EARTH POETRY COLLECTION

SCOTT MANLEY HADLEY & SEAN PRESTON

Sean Preston and Scott Manley Hadley are flat earth truthers first and poets second.
Sean Preston is a Father. Scott Manley Hadley has a Dog.
Sean Preston is Balding. Scott Manley Hadley is Bald.

Sean Preston's poems appear in bold.
Scott Manley Hadley's poems appear in unbold.

THE EARTH

CONTENTS

Contents
Page 2

Dedications
Page 4

Content warning
Page 7

Poems
Pages 9 - 106

The Conversation
(a conversation)
Pages 108 - 133

THE EARTH

I dedicate my work on this book to Sean Preston, as long as he dedicates his work on it to me.
Scott Manley Hadley

To God/Jesus, and the fine gentlemen who said not, "I blindly accept what you are telling me because I am a sheep or some other easily led animal," and instead, said, "I blindly except what you say."
Sean Preston

Alas! for a phantom goal and the globites' fancies rare!
Alas! for earth's axial pole. Alas! for it isn't there.
Lady Blount, 1909

IT'S FLAT

CONTENT WARNING:

In keeping with the themes of exposing truth, Scott Manley Hadley has decided to accompany each of the following poems he wrote with a professionally-shot fully nude photograph. Though these are not erotica/pornography, genitalia is visible in many of the images, so sensitive readers are advised to pass on to the following page before they have seen anything they do not want to see. Thank you.

The photographs accompanying Sean Preston's poems are not fully-nude, nor are they professionally shot.

IT'S FLAT

Prove to me the earth is round.
I do not trust photographs: they can be faked
I do not trust the testimonies of astronauts
(((((ACTronauts)))))
I do not trust
Equations
And Physics
I trust the flat horizon.
I trust
REALITY

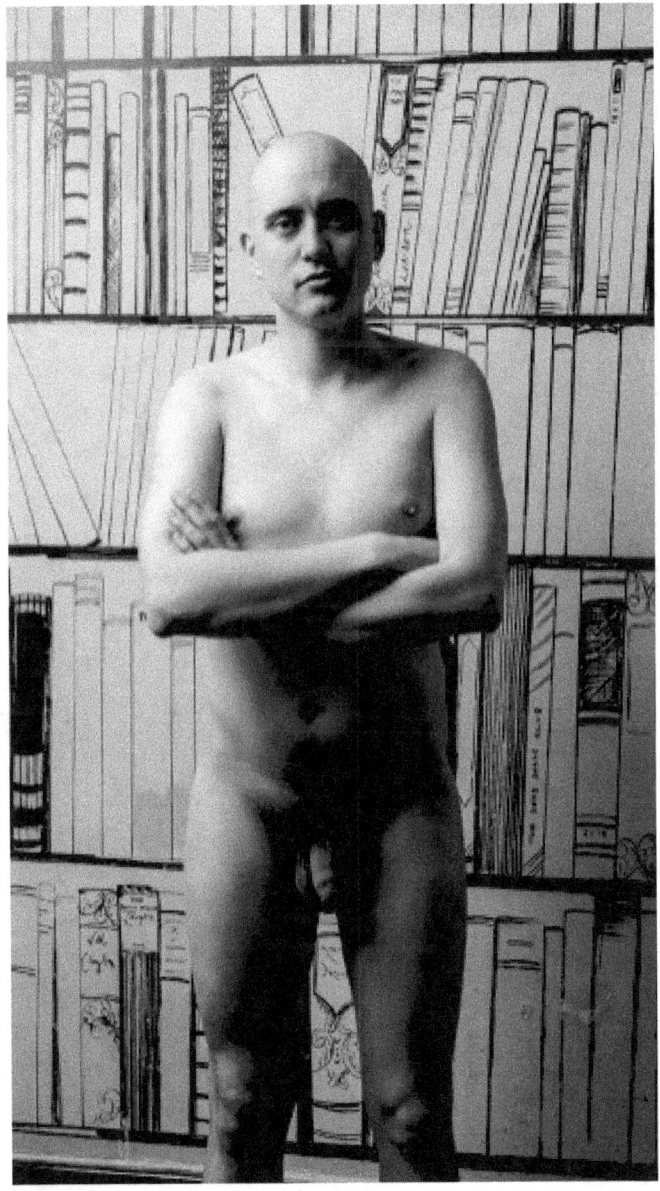

Who benefits
From the round earth fiction?

The oil people
The water people
The meat people
The fish people
The air freight people
The shipping people
The space people
The logistics people.
The people who
Do not want us to build
Hydro-electric turbines
Hanging over the edge.

We do not need oil
We have free energy
Falling
Unused
Around us.

If you believe in the round earth theory
You are supporting
Big oil.

You are murdering Mama Earth.

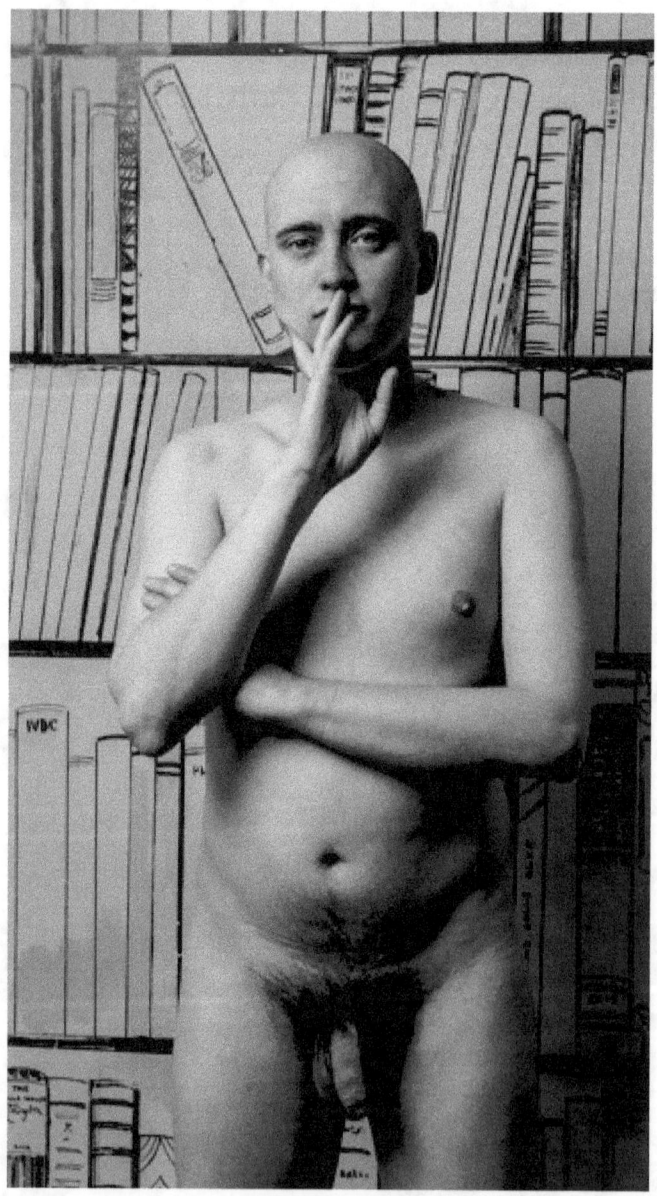

Australia does not exist.

The world's edge is hidden.

Have you been to the Antarctic?
No.

Nobody has.
Nobody will.
They fake it in the mountains.

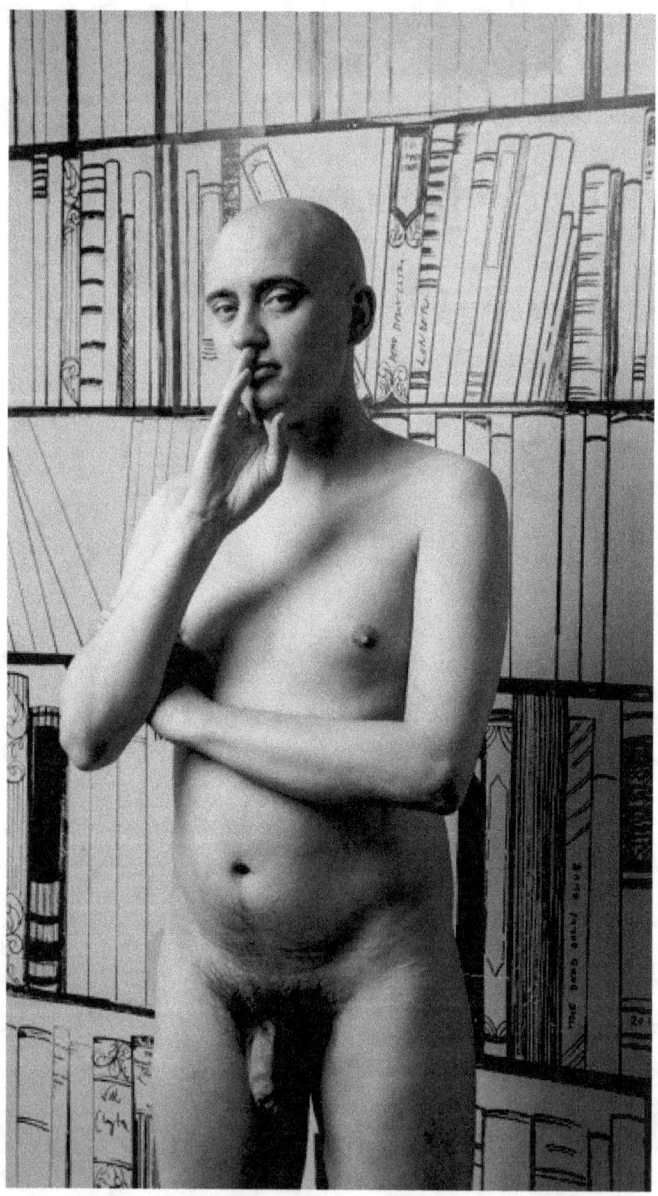

All the most powerful ideas
In humanity's history
Have required a leap of faith.

If something is worth believing
It will not be believed by the crowd.

If something makes you question
Things you have believed
That you have never questioned before
Then there is always something to that.

Why do we believe the Earth is round
When we are children?

The same reason we believe "property" to be "theft":
It is what they teach us in school
And on BBC
And on CNN
And ITV

And NBC
And CBC
And ABC (the Australian one)
And ABC (the American one).

We are brainwashed by
Authoritarian
State
Media
Murdering Our Intellects
Our Freedom
And
Our Firm grasp of Randian economic theory.

Only money is as powerful as truth
And money, like the earth... is flat.

(Even a round coin is flat
When it's on its side
But coins are just
For toothfairies)

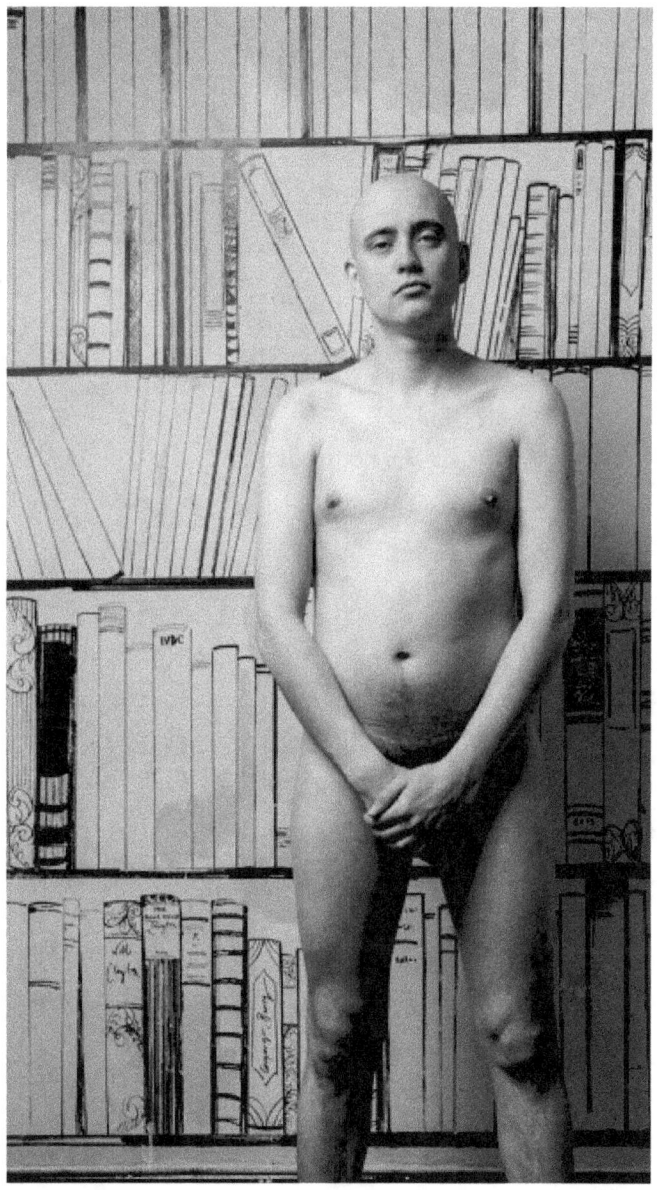

When you kick a ball
It rolls
When you kick the ground
It hurts.

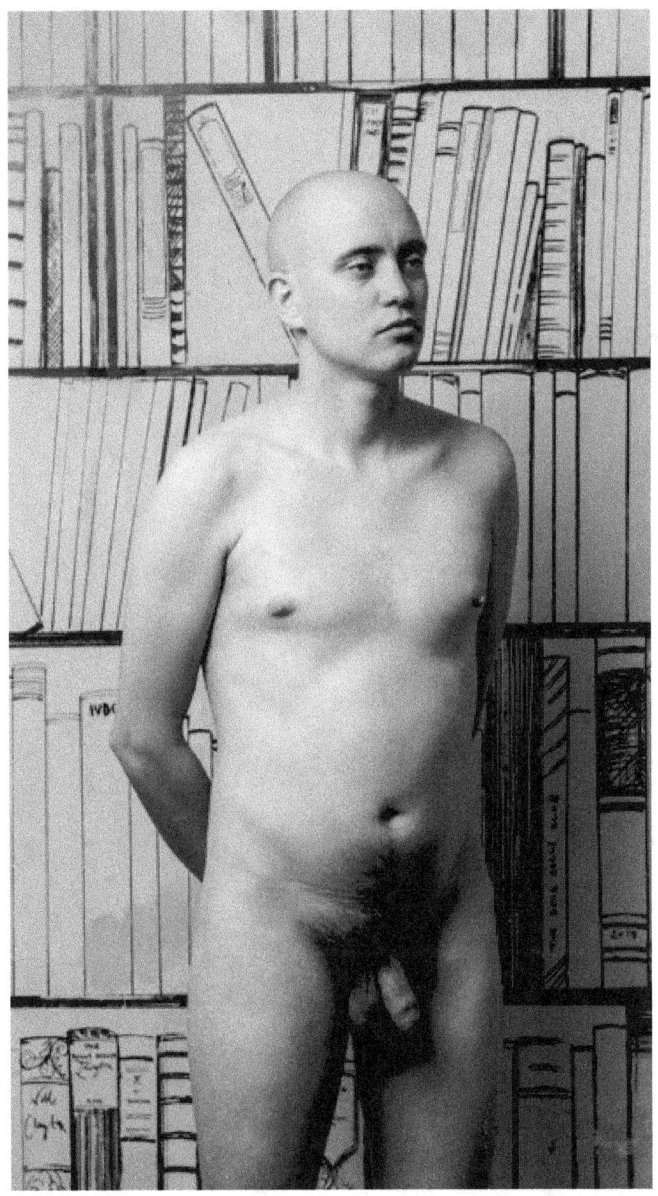

The horizon
Is straight.
The Earth
Is flat.
It's not fucking
Rocket science.

IT'S FLAT

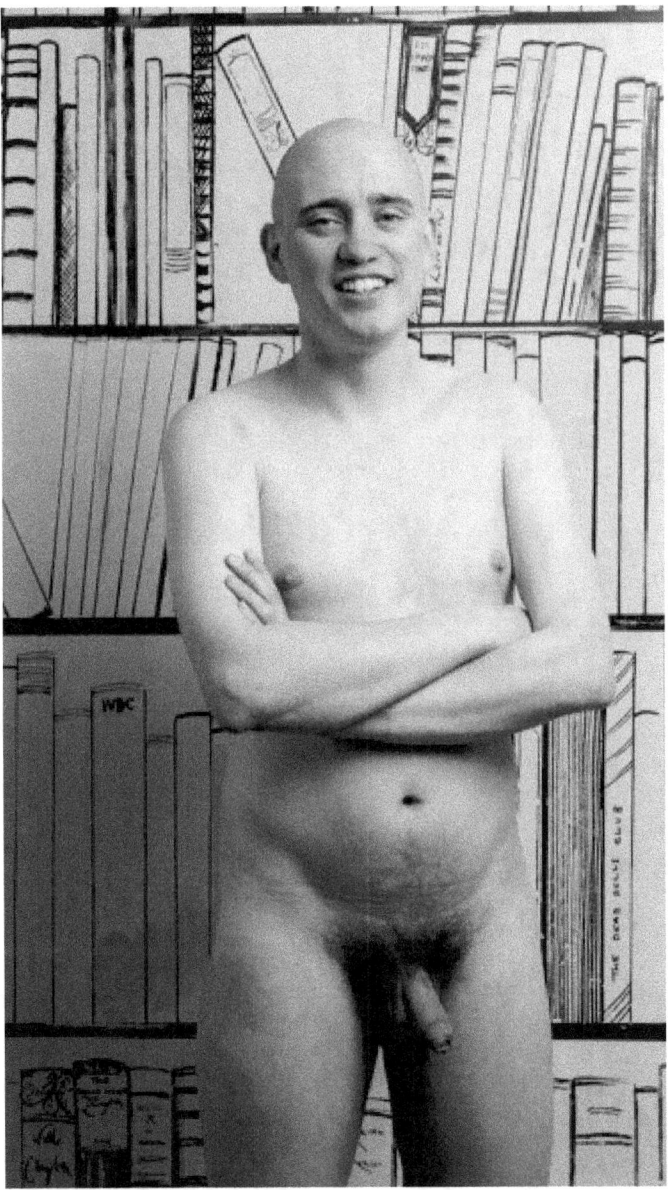

Cher sang
"Do you believe in life after love?"
I sing *nothing*:
Because I believe we should only shout
Until
The truth is out.

Do you believe in the truth of the flat earth?,
Cher?
Do you?
Do you?
Do you?

NB: Cher, if you're reading this, then please do email (trutherpressbooks@gmail.com) letting us know your thoughts on this.

IT'S FLAT

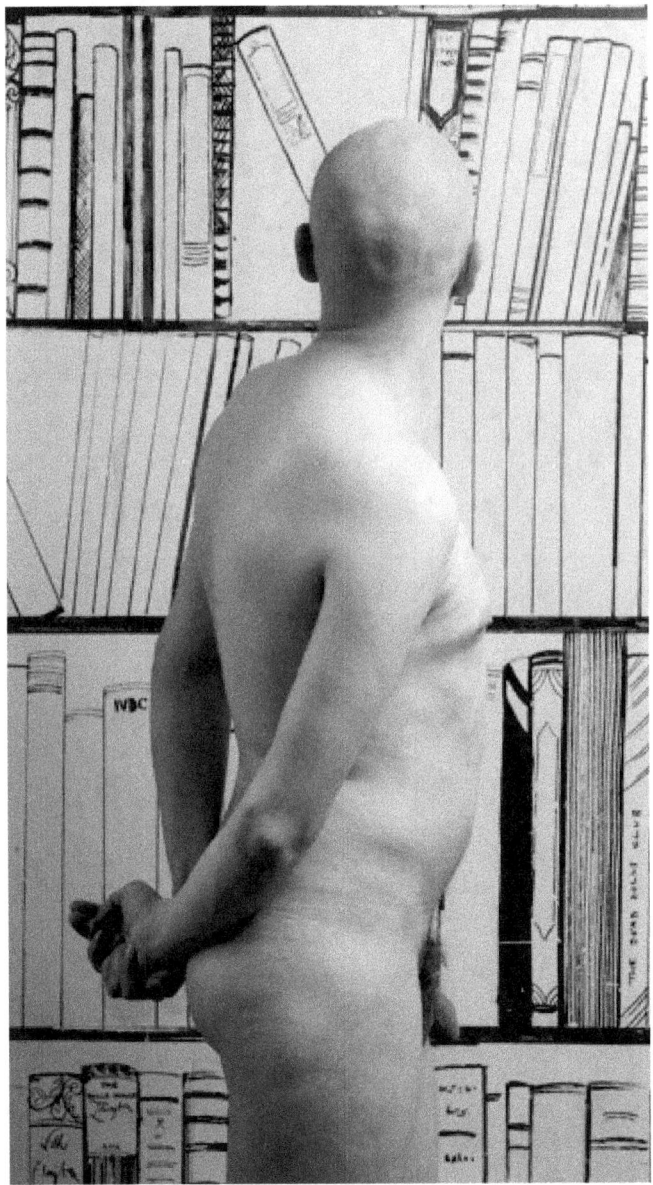

THE EARTH

If the earth wasn't flat
I'd fall over
Sober.

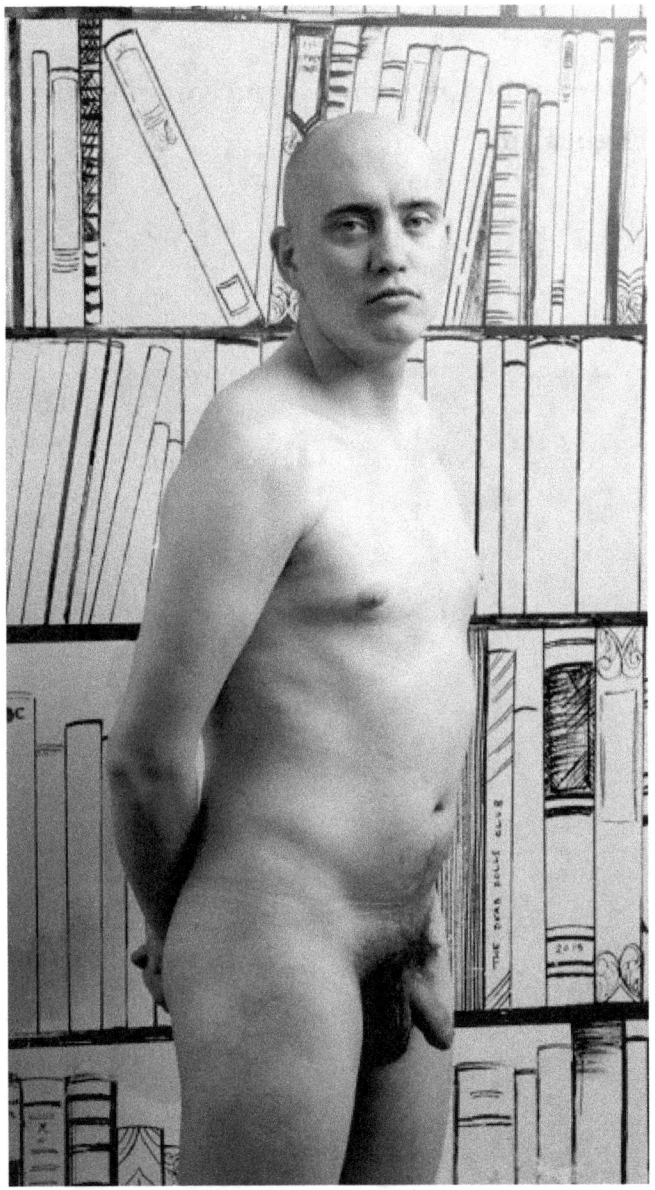

I stare out of my window and contemplate Flight Paths

Promotional photograph for the book 'Because Earth Is Flat'.

© Mum 2019

The earth is as flat as a pancake
To say it's not
Is a load of *crêpe*.

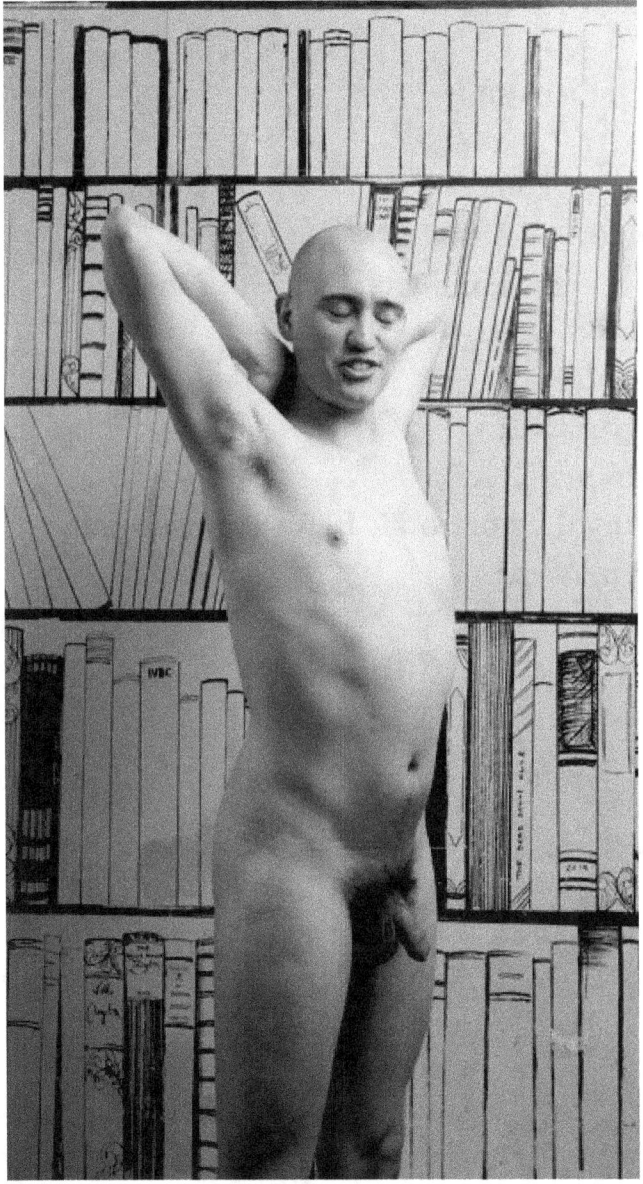

**So it's round
Is it?
Funny that
Mr(s) Scientist
Because from where I'm standing
Looks pretty flat.
Explain
If you will
Mr(s) Scientist
Why the horizon is higher than the floor
at my feet?**

Scott Manley Hadley's last title with Truther Press. I'm still trying to catch my breathe tbph.

© Scott M. Hadley 2019

Important notice: Scott repeatedly asked me (Sean Preston) to remove the word "Dr" from before his name, as he isn't a doctor and doesn't have a PhD. However, as I couldn't find any evidence that impersonating an academic is a crime I refused to do so. Scott doesn't know how to use InDesign and there was nothing he could do to stop me. Due to legal action, however, we are now unable to sell "The Truth About Stone Henge", even with "Dr" removed. To contribute to our crowdfunder to recoup our legal fees (generously provided by four MasterCards made out in Scott's brother's name, Steven Manley Hadley) please visit tinyurl.com/£€¥£¥¥$$$$$$$

**Fear
And snakes
Combine to make
Sfear (sphere)**

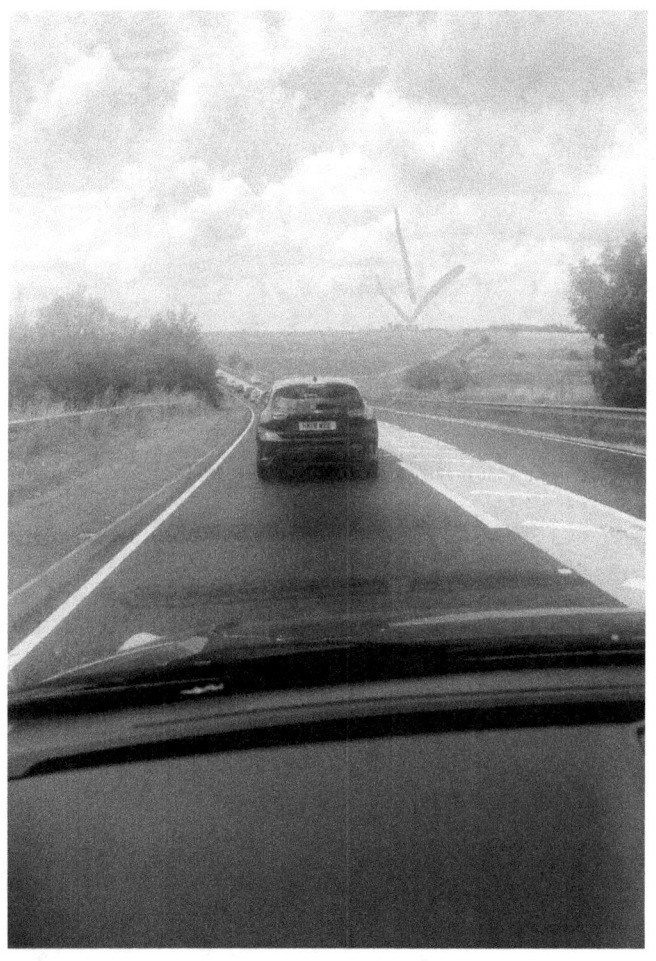

A photo of Stone Henge. The same road goes right by it but I was on 1% battery. Poor planning or ancient druid aliens scuppering my investigations?
© Me/ 2019

There are tens of thousands of us
and how can that many people
Be wrong
About ANYTHING?

THE EARTH

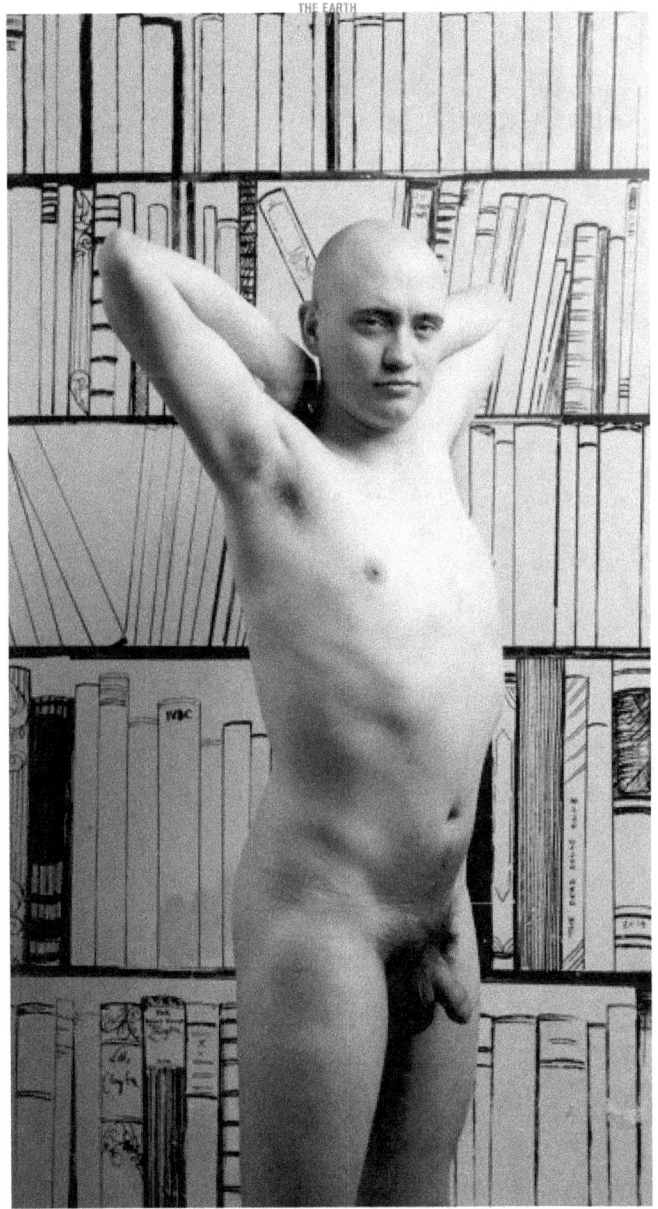

IT'S FLAT

I know the truth about the shape of the Earth
And no, mom, I won't shut up about it

THE EARTH

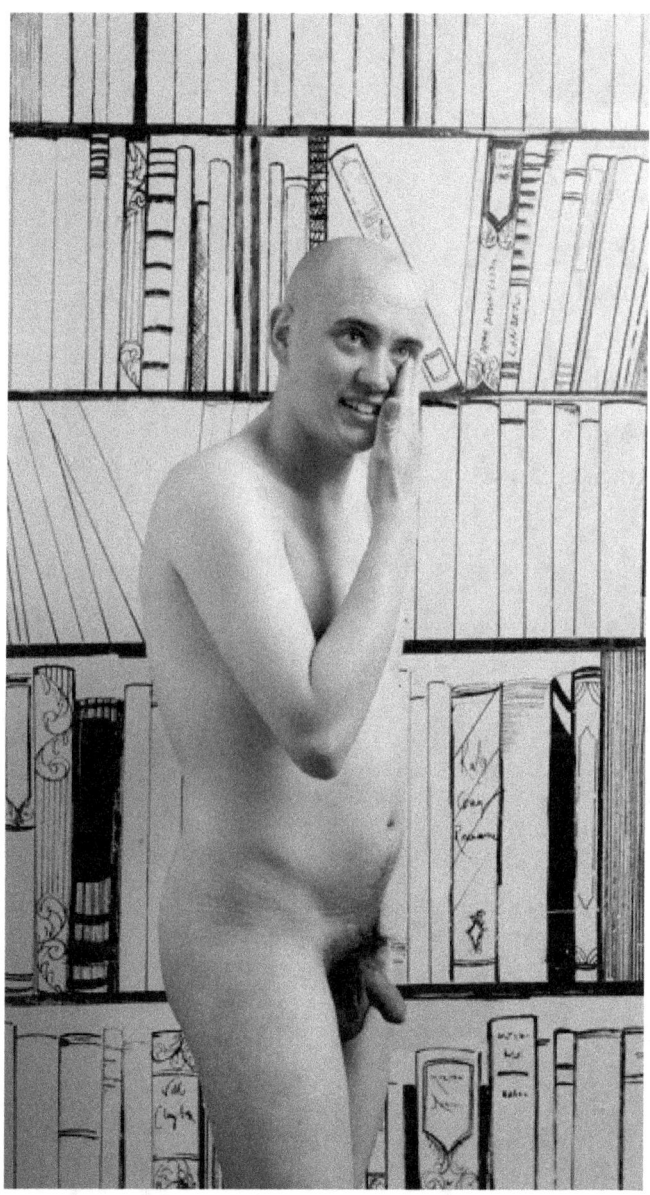

if
the
earth
was
round
we
wouldn't
need
Wheels

THE EARTH

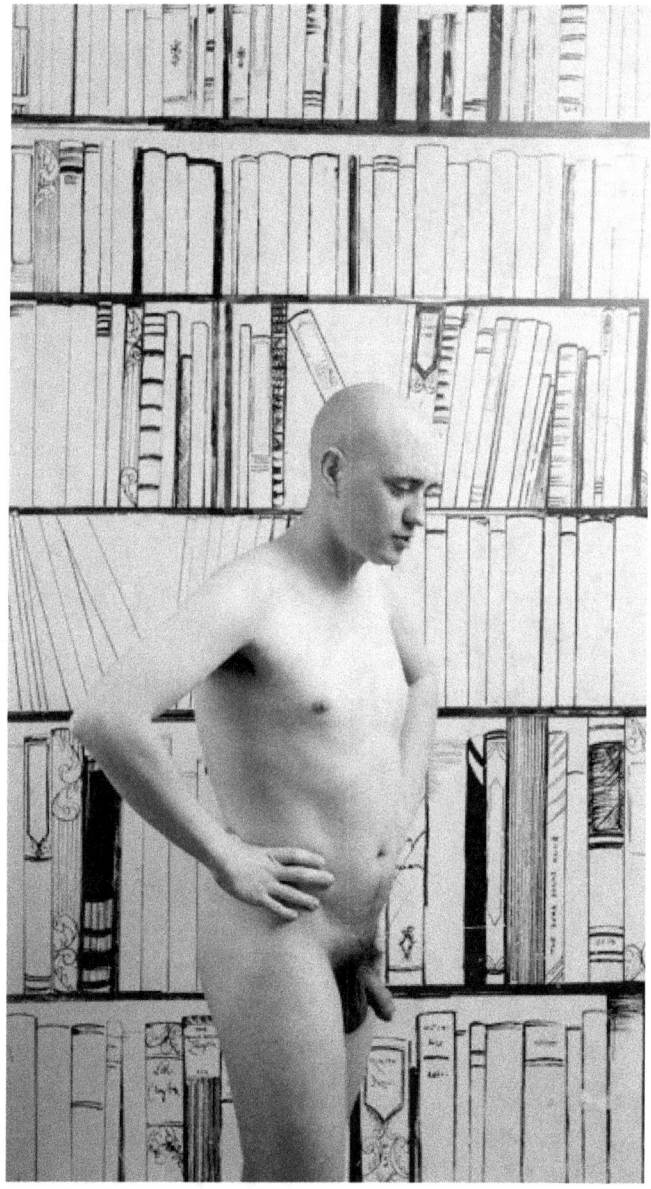

yes, the earth is very
very
very
very
very
very
thick
but that doesn't mean it's round

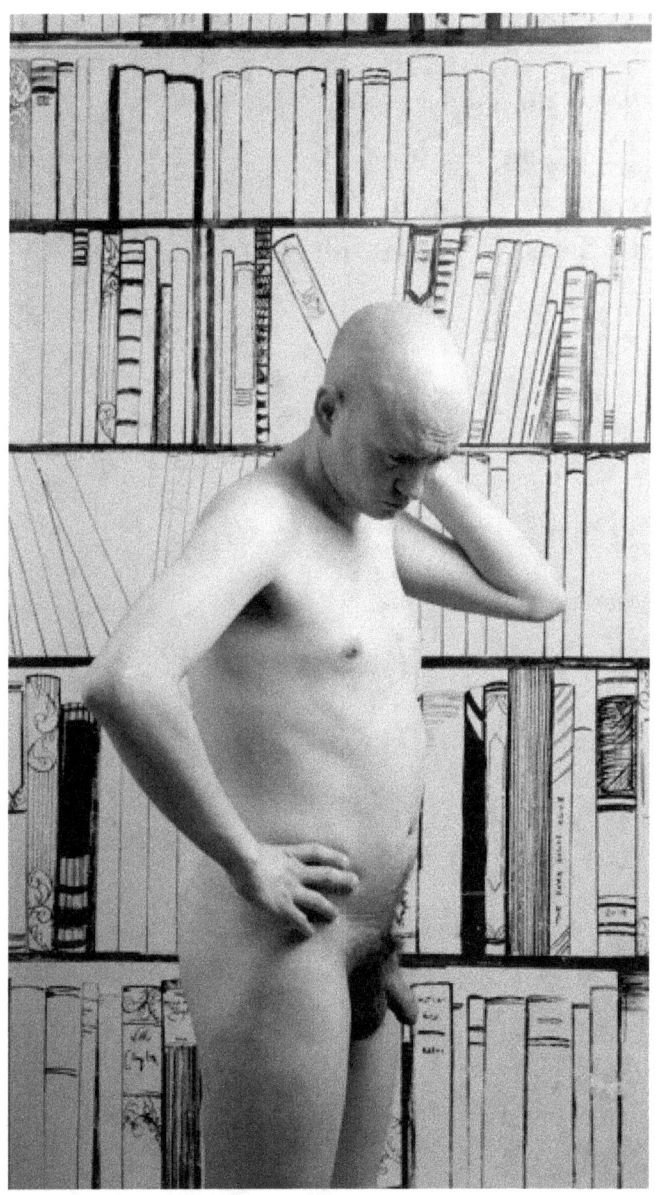

We are simple creatures
flesh monkeys
we copy what we see
so if the earth wasn't truly flat
neither would our tables be

THE EARTH

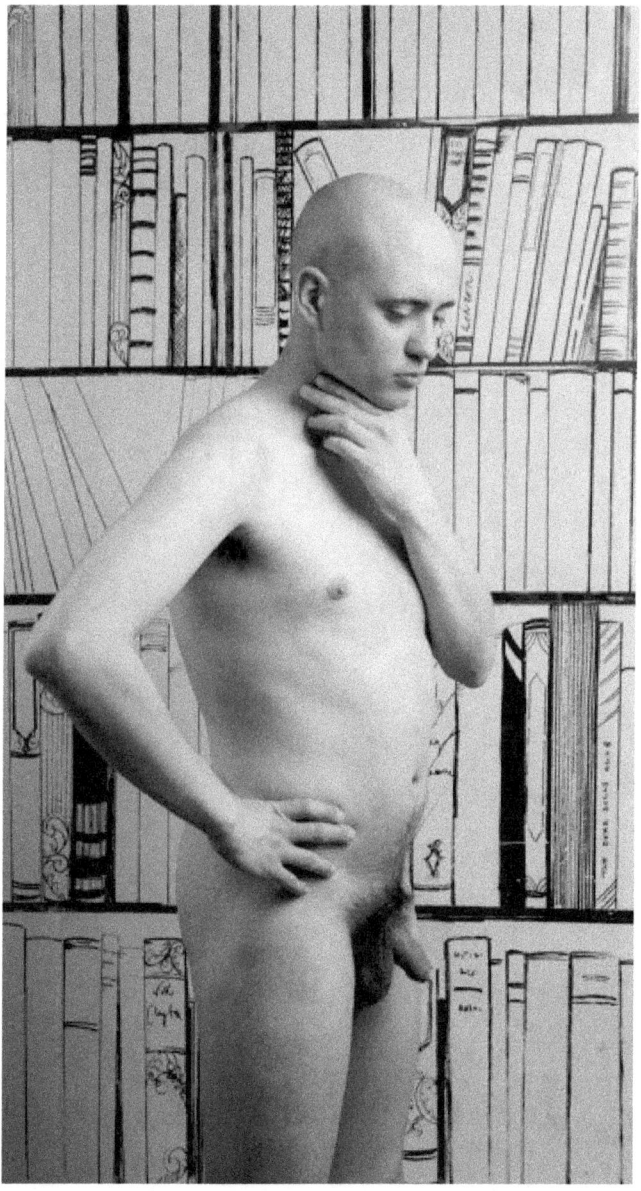

if you raise your children
to believe in the false globe narrative
then you are no better than HEROD.

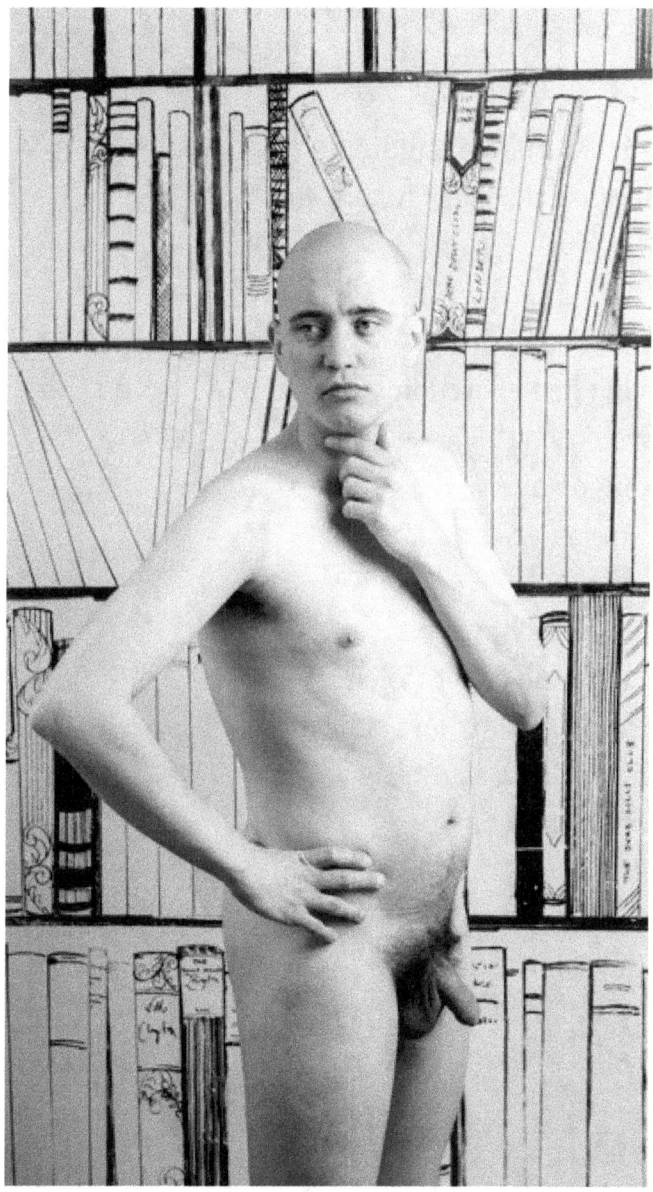

Herod was a King
Who murdered children
Because they may have been
Messiahs.

He stood up for
What he believed in
Even though
It made him
Unpopular.

I'm not saying
We should enact violence
On those who don't believe
In the Earth as it truly is
But I am saying
That Herod
- unlike globe earthers -
Had *some* redeeming features.

THE EARTH

Stability, control, poise
That must be our superpower
For us to maintain our balance, hurtling through space at a million miles or kilometres an hour.

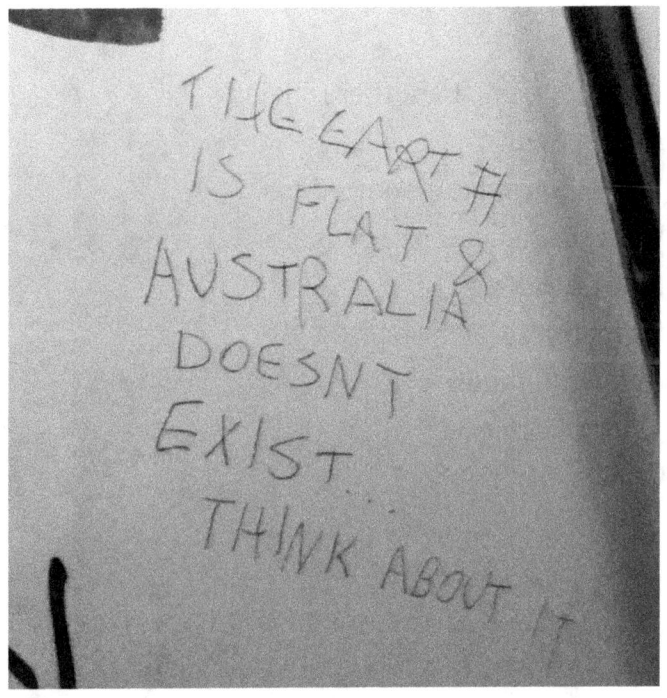

Makes you think.
-Found graffiti poetry, 2018
--Is it still "graf" if it's speaking truth?
---Scott says it is.
© Unknown - found graffiti poetry, 2018

"Science" is just another religion
Another cult
We are vaccinating our minds
With the bullshit of a conspiracy
Made to keep
Us ignorant.
And we all know
That vaccination
Causes cancers

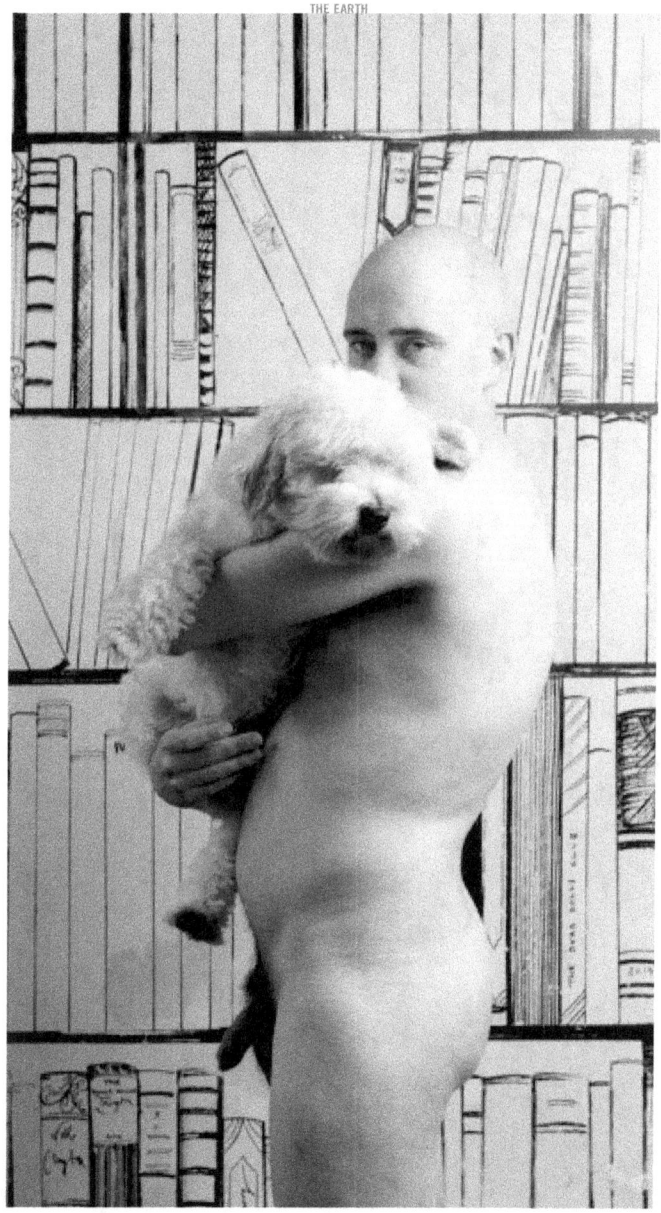

Disbelief
In the true shape
Of this terra disc
Is an intellectual cancer

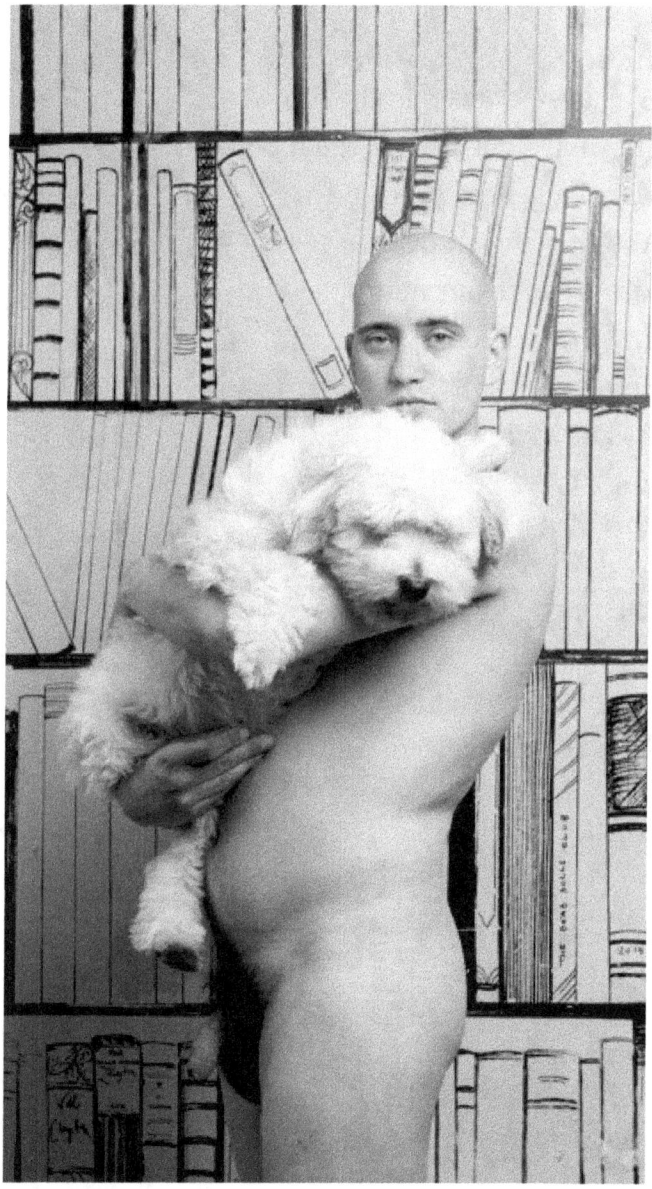

We have not been to the moon
They have not been to the moon
They have been to the edge
And they hide it from us
Like we hide our nudity
From each other
Because
It is terrifying to see
But
IT
IS
THERE

IT'S FLAT

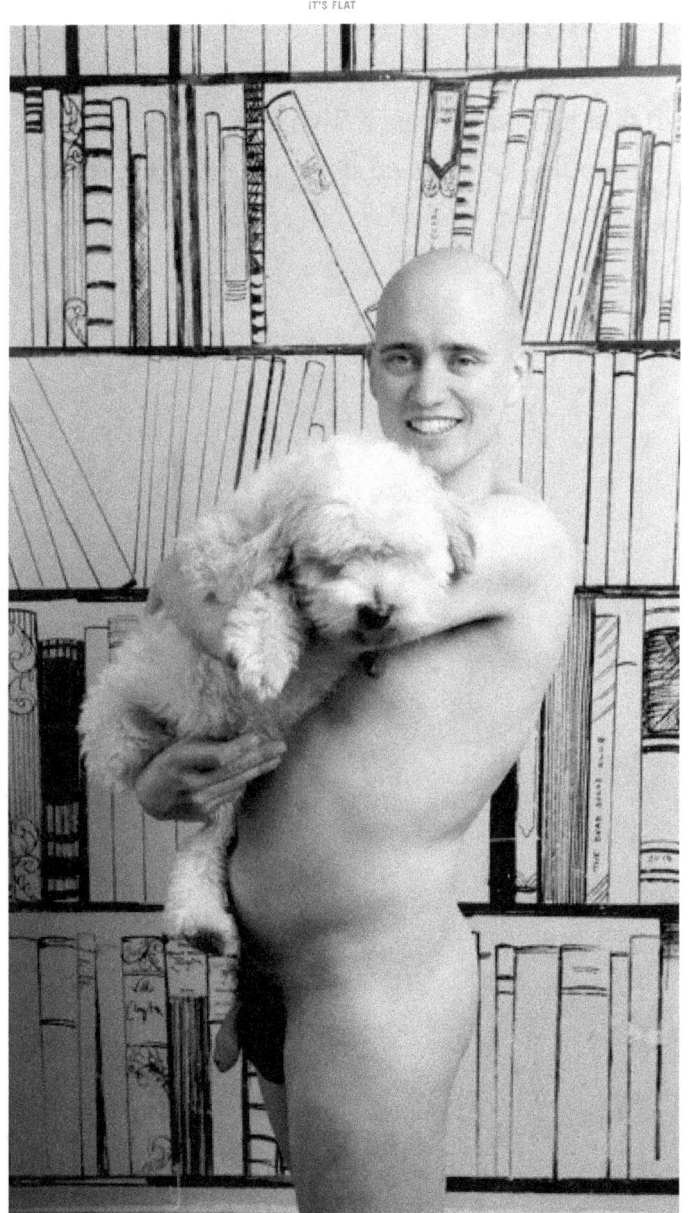

THE EARTH

If god had wanted us to live in a round world
He would have placed us on a round world

IT'S FLAT

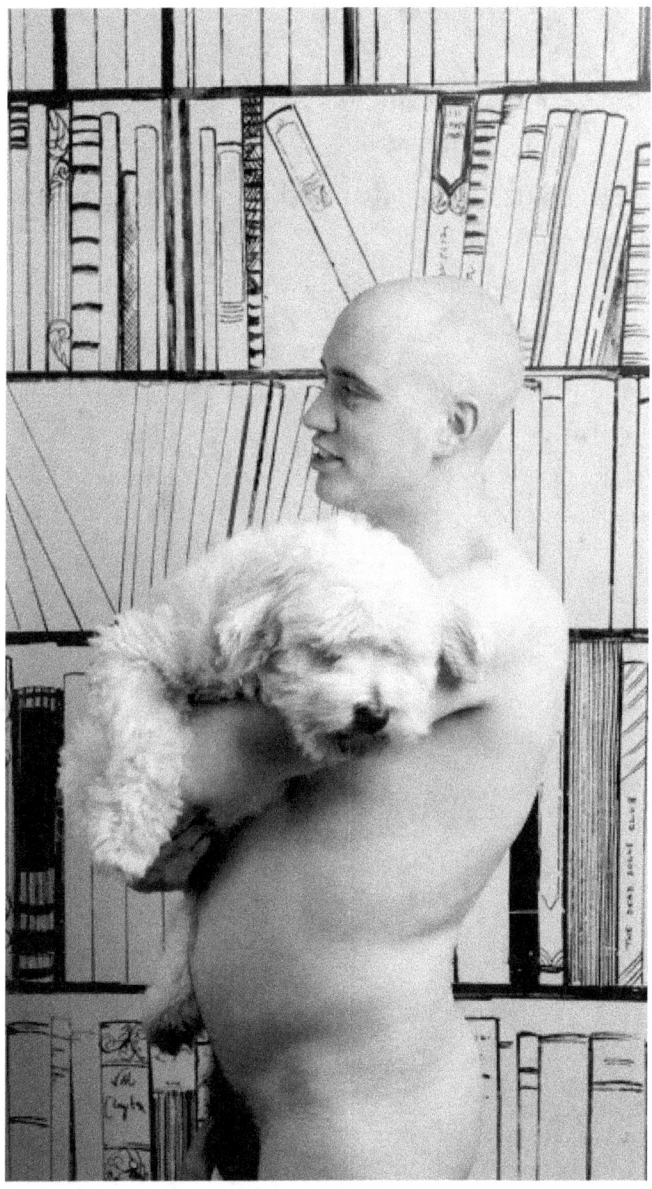

They call us ignorant
They call us fools
They call us medieval atavististic anti-scientific morons
We call them
Woefully
Woefully
Woefully
Misled

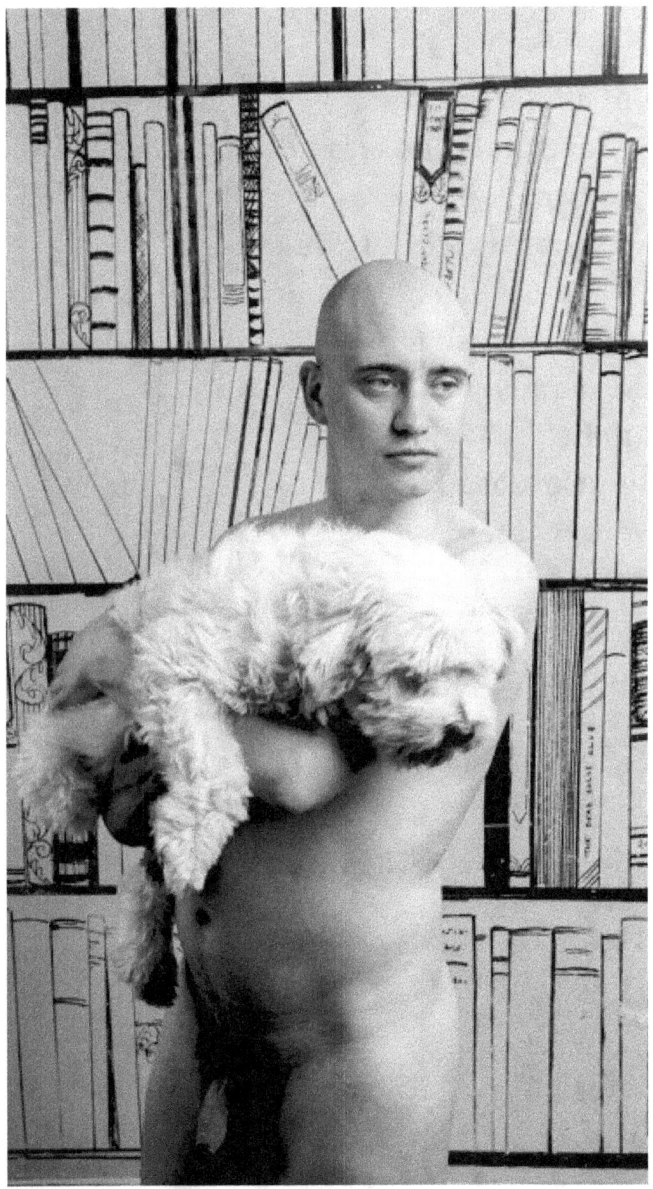

Not all flat earthers
Believe that dinosaurs didn't exist
The two
Are not inextricably linked
Tyrannosaurus Rex roamed the earth
And if you ask me
He roamed it flat
Or she
Some dinosaurs
were women

I find AirBNBs a great source of inspiration. They are nearly always decked out in beautiful poetry art like the above, which inspired me to tears during an otherwise rubbish trip to Dorset.

© Me - with thanks to Ken and Linda, 2018

Around the world in 80 days
Or across the world in 80 days?
Either way the movie is not very good.

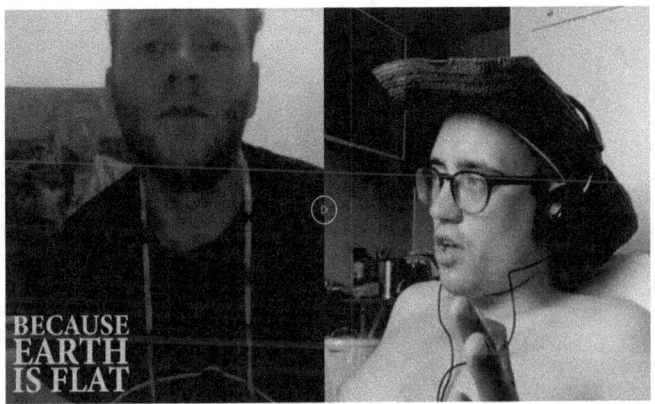

A still from the hour long conversation vidcast with the authors of this book. You can check this out now on online.
© Sean Preston, Scott Manley Hadley.

THE EARTH

It is easier for a rich man to enter heaven
Than it is for a round-earther to do so

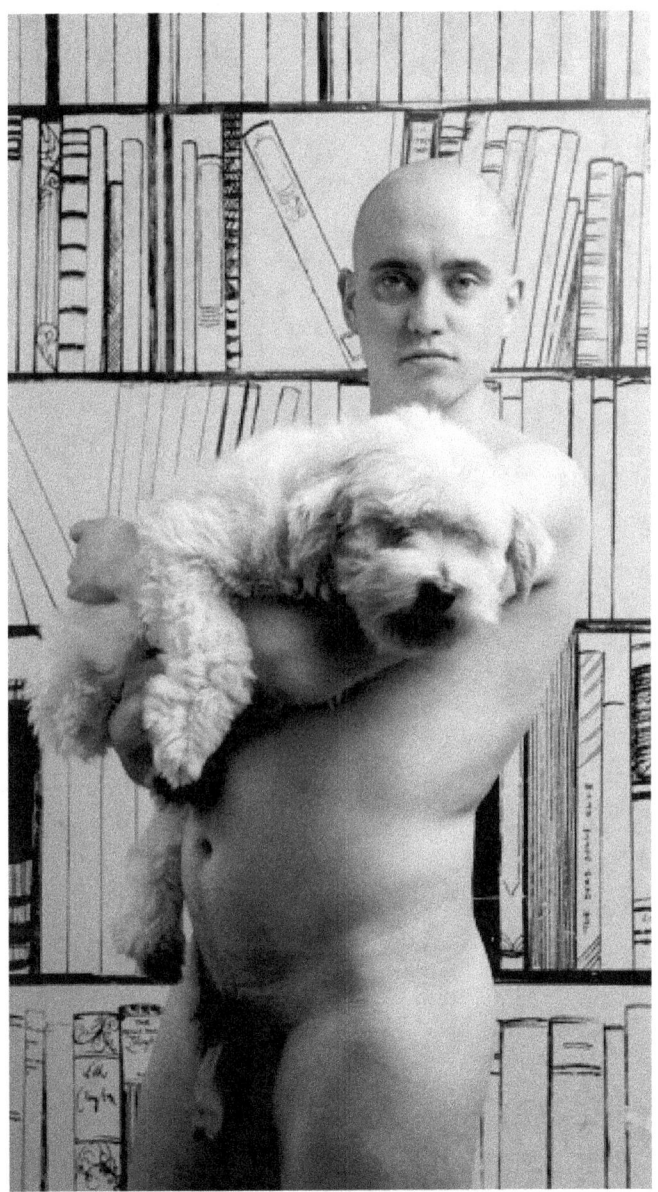

Flat earth is the only theory
That proves itself

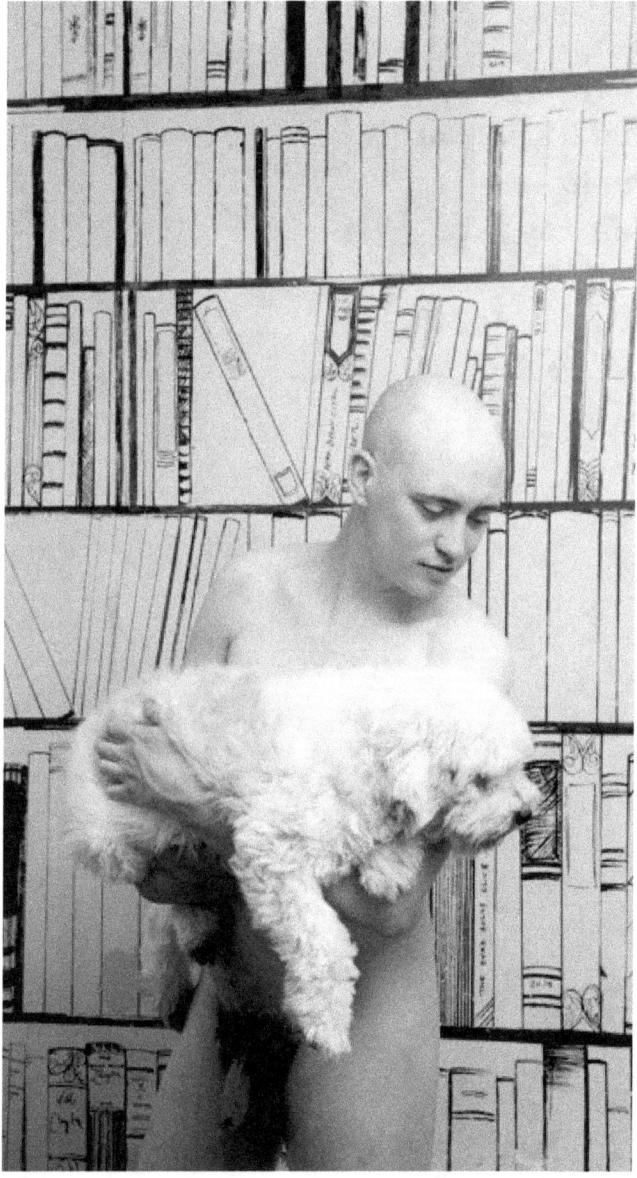

**I don't believe
that it's *not* flat
Put it
that way**

Scott can you find out if the printer can make the GIF like one of those 3D magic motion things.

We all hate balls
We all love frisbees
This is proof
If your eyes are open

IT'S FLAT

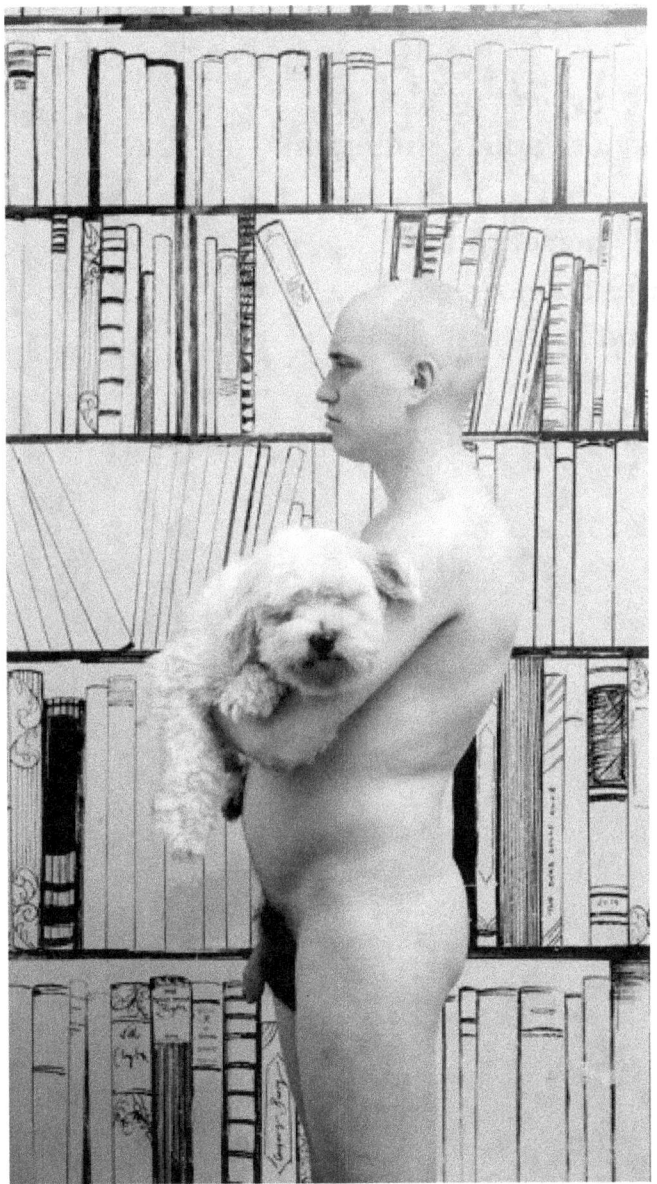

My perfect woman
Is not Pamela Anderson
No
My perfect lady
Has a flat chest
And flatly refuses
not to be
Flatulent in front of me

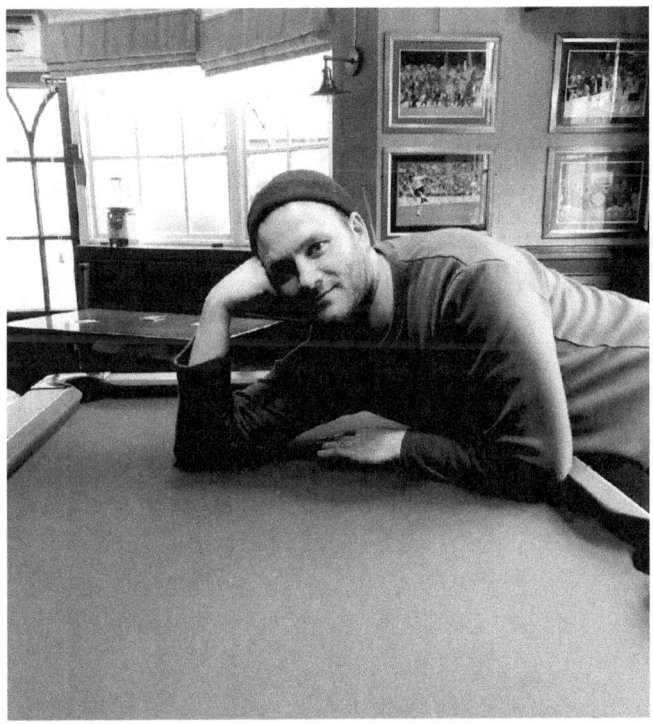

Promotional photo for 'Because Earth Is Flat'. You probably won't work this out yourself, but it's explicitly an allusion to flat earth (the pool table is flat).

© Truther Press, 2019

THE EARTH

**They all laughed at those who laughed
at Christopher Columbus
When he said the world was round
Well who who who?
Who's got the last laugh now?**

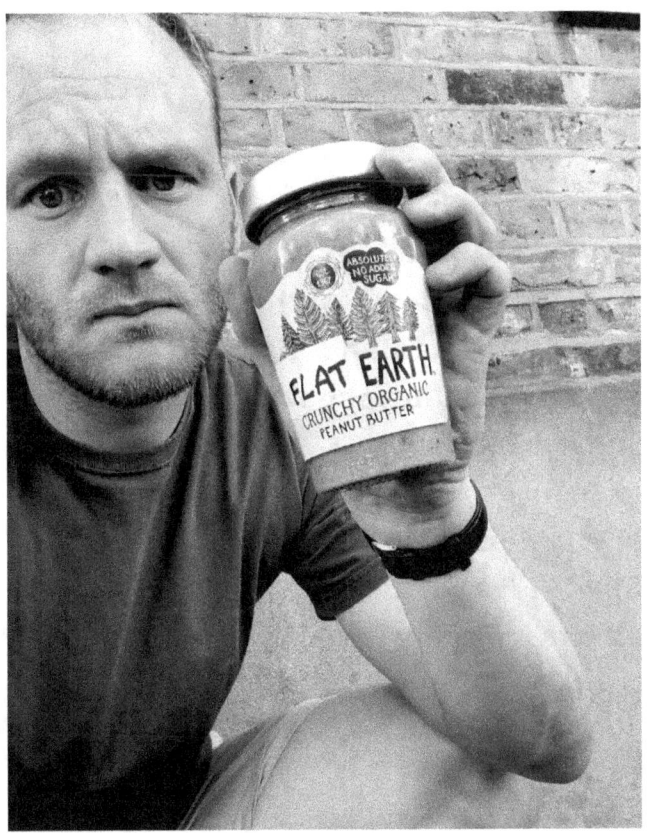

A good way to stay "in-truth" is to rebrand everyday household items like the above. Although this royally fucked me over once when Steven sent me a ticket to Flatitude Festival but it was nothing to do with the flat earth truth festival I wanted to go to other than George Ezra was still headlining.

© Truther Press, 2019

**When I came
out
as a Flat Earth TRUTHER
people said to me, but planes fly from
Australia to the USA all the time. Are
you saying that planes fly from Australia to the USA the long way round?
That's what I'm
up against
Google flight paths
Google Flat Earth
Educate yourselves
Bigot(s)**

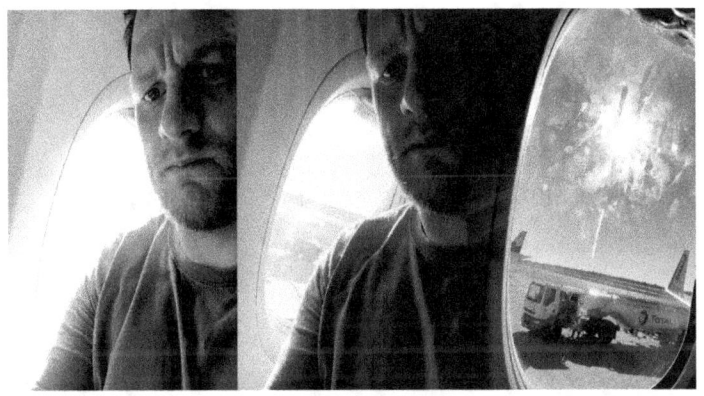

I got on a RyanAir to prove that planes don't actually fly, they just simulate a flight for a while. My flight was delayed by 3 hours. Stalling tactics. That's why they make you go in airplane mode. They want to shut your shit down so you can't send updates to Scott on whatsapp. Third image in this tri-image above is to show the production truck where they simulate the birdseye visuals of when you are "flying". That window you see is actually a high tech screen. I smeared it with grease from my fingers after eating a pack of Doritos Tangy Cheese, and guess what? The smear was still there on the images broadcast to my "window" by the production truck.

Case closed.

© Truther Press, 2019

This is the flattest of all possible worlds
And
The most flat anything can be
Is completely flat.

Ergo (which means therefore (which means so))
The Earth is flat.

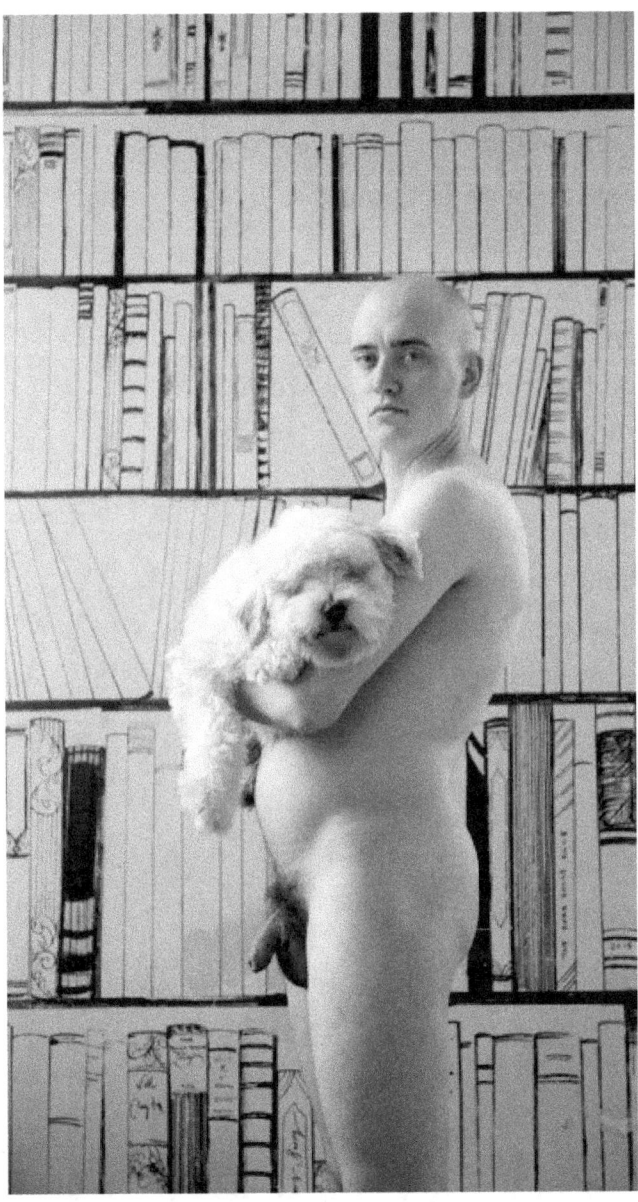

IT'S FLAT

People say
About things they can't handle
They are like a hot potato.

But a hot potato
Is round
And the true shape of the world
Is not.

Who complains
About holding a hot pancake?
Who complains
About holding a hot plate?

Flat truths
Are easy to handle
As long as your hands
Are strong.

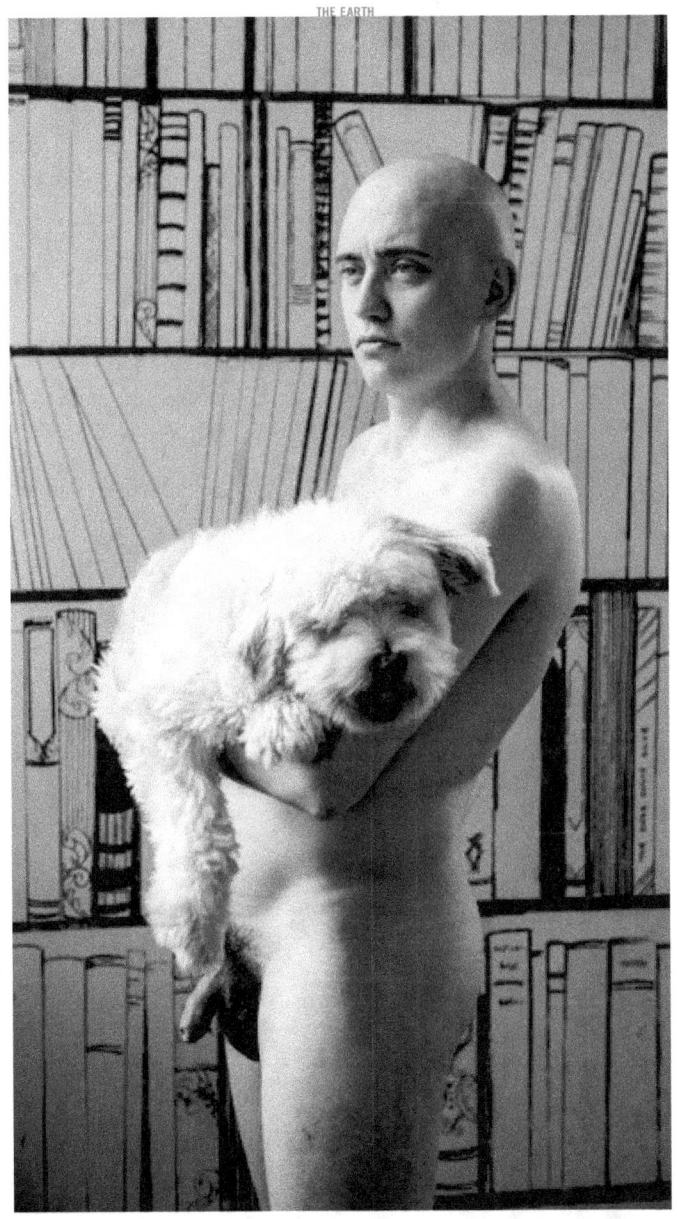

**You know it
I know it
Globalisation is bad**

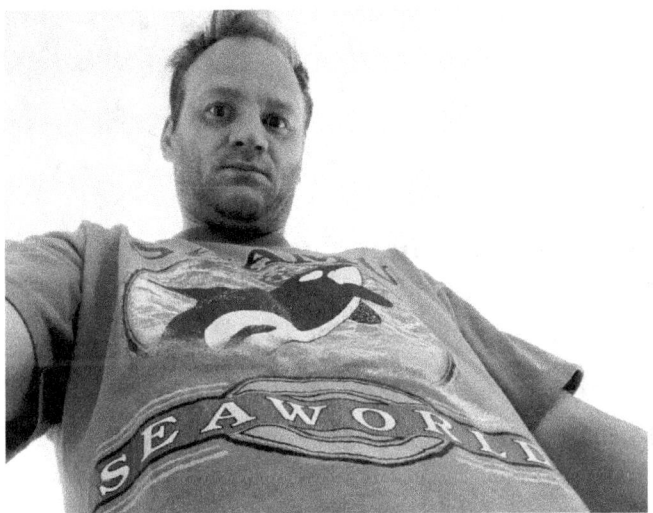

Most selfies are taken from a high angle to flatter the selfieer. But then most people believe the Earth is a fricking globe. Stop lying to yourself, people.

© Sean Preston

-With thanks to the Shamu family.

Alone and afraid
Discarded
A laughing stock
That's where you'd have found me
Before
finally
I stood
Flat against my brothers
Flat against my sisters
Flat in line
Flatly refusing
To be alone and afraid
To be discarded
We are a stock
But not a laughing stock

(Not to each other.)

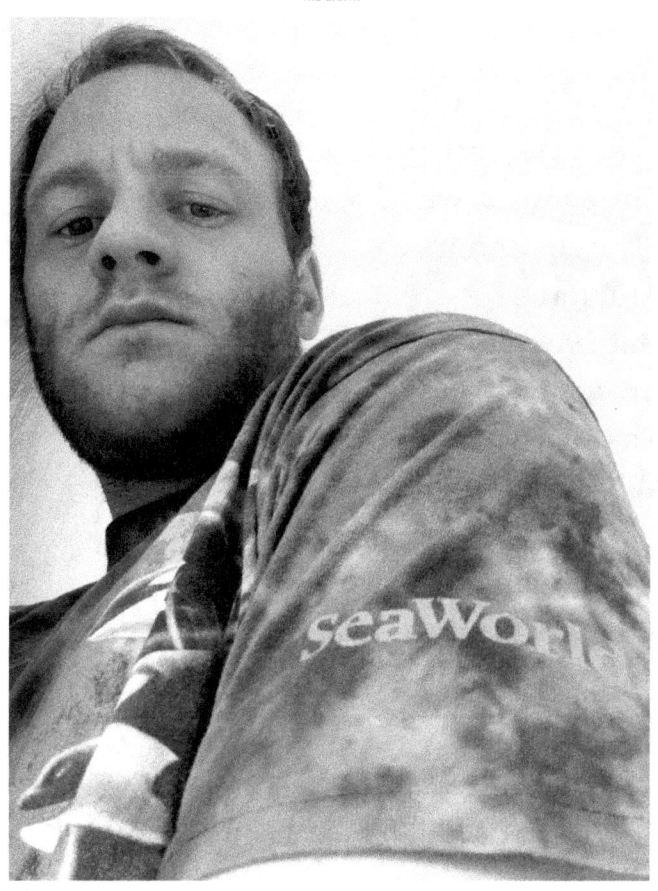

felt cute
can't delete

© Mum

How do we build
When they accept that it's flat?
The same as we have always done
Straight and true.
And flat.
But how do we build the metaphorical bridge?
To those who believed
Without doubt
That the Earth was round
Until we proved otherwise?
What bridge can we summon?
For our friends
Our family
Our loved ones
Those disconsolate Round Earth followers.
I hope we build it flat
Yes
But we must build it true
Too

We must draw on our experiences
Love conquers all
Plus
After all
You cannot draw a love heart
Without making it round
and flat.

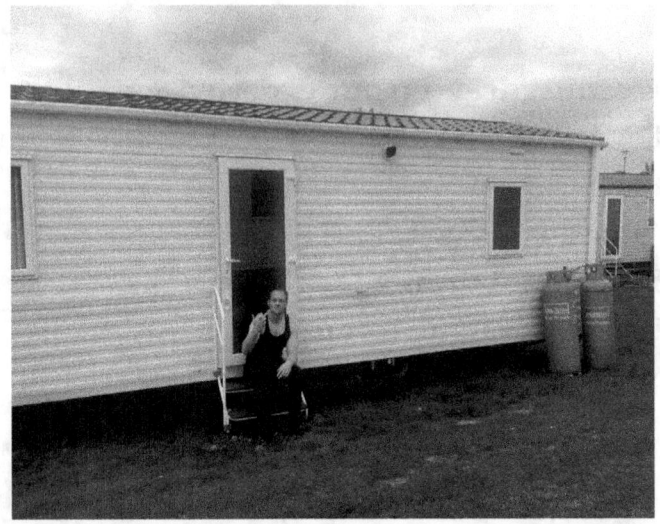

This was taken seconds after composing the above poem. The poem was originally intended for a battle rap battle at Haven and I was drawn against my wife, [name redacted due to legal action]. She bottled it big time and conceded before the contest (fear is only a four letter word, but I had a few more of those for her at 7pm in the Tiger Bar). Unbeaten, I felt invincible, the power of that perceived invincibility went to my head, and, regrettably, I instructed [name redacted due to legal action] to take a photo of me sticking one finger up in the air before sending it to my nana.

© [name redacted due to legal action]

-RIP Nana.

Metaphorically the earth
Is more like a door than a ball
Literally it is too.

Not a round door
Nor a flat ball.

We have flat doors
On this flat, lovely, earth.

IT'S FLAT

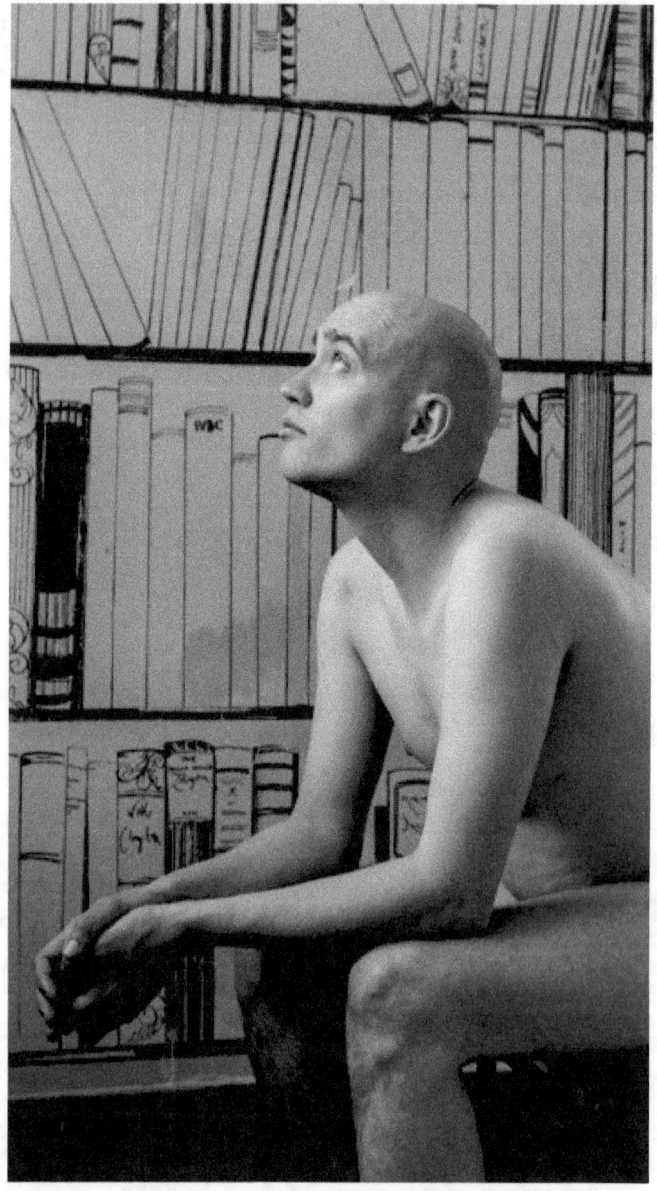

Can there be love?
Like the romantic stuff
Between a Flat Earth Realist
And a Round Earth Wrongist?
When is love wrong?
Can love be wrong?
When I fall in love with a bae
on the train to work one day
I'll wonder to myself whether she too
is one of the open eyed few

Flattery, she'll say, will get you everywhere.

And I just

If she strolled upon a beach clinging to me
Gazed out upon the horizoned sea
Would she say aloud from where we sat
"What a gorgeous sight, it's so very flat."

You wouldn't believe the overlap between the Flat Earth and Competitive Eating scenes.

© Steven

Flat earth
Fat earth
Fat earh
Fat ear
At ear
At ar
At a
At a
At a
At a point in our cultural development
Where we can
Finally
Handle the truth.

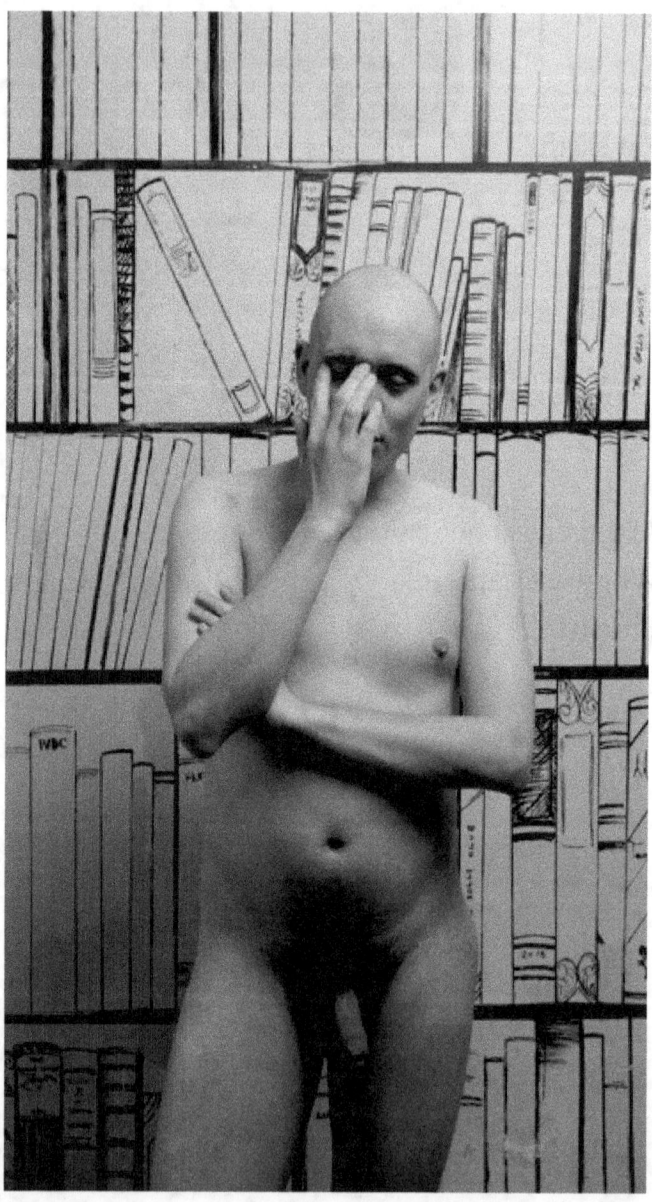

**Whether Flat Earth
Or bullied TERF
An open mind is a weapon of
deconstruction.**

Flat Earth tattoos are frowned upon by some subsections of the community, but personally I don't care what Linda thinks.

© Sean Preston

Imagine falling in love with someone
And then discovering
They believe in the round earth theory.

Imagine the shame you'd feel
The heat of regret
The crush
The sweats
The pain.

What if
You'd introduced them to your friends
And family
And they'd all realised
And laughed at you the whole damn time?

What if you didn't find out until your wedding day?
Or - so much worse - until the sad day after?

What if
You didn't realise

Until the birthing pool/the end of the adoption process [1]
Or
The minute after
You've signed the mortgage
You come round post hysterectomy
Or vasectomy
After you retire
After you book onto that cruise
To finally go
To see the edge.

You are
Dying
You have weeks left
And your lover says,
You sat on the deck
Feeling the current pull the ship harder
Towards that edge.
You hold the oxygen mask
Tight against your face [2],

Your weak bones ready to crack
That alien future cancer in every cell of your body
Like denial in so many minds
And your lover says,
"What edge?
You've waited your whole life to see what edge?"[3]

And you weep
And die
Of a broken heart [4]
Before you see it.

Because you wasted your life
In love with a fool.

[1] Of course, there are other ways to become the lead carer for a child: fostering, finding, birthing in a place that is not a birthing pool. However you come to care for a child with a partner is valid, and the poem is here trying to draw attention to that fact, alongside clarifying that it's a big commitment, however you enter that caring relationship. I mean, I presume it is, I wouldn't know, but I have a dog and that can be hard work sometimes, and you can teach children to poo in a toilet rather

than in the street, so it's probably a bigger and a smaller commitment at the same time.

2 You are dying, but your lover is not: this cruise is happening in the far distant future and, yes, medicine has become so good that you are able to be one hundred and twelve and still look fucking phenomenal and be in peak physical health so your lover is still young-looking and gorgeous so you know that after your death they will 100% find love and great sex again, so there's an important bitterness to your imminent death because right now you think you're sharing your final moments with your like total dream person, an illusion which will be shattered. The reason why you're dying in this scenario but they're 112 and about to start banging people a quarter of their age is because you've got some like alien future cancer that is still fatal in the future, because you caught it doing something crazy fucking heroic, probably like killing loads of sinister aliens on a distant planet right next to a dirty sun and you had to like fight the aliens with your bare hands and even your jaw or something, and the diseases on their planet are so different from those on Earth that human future medicine - even though it can arrest ageing and guarantee erections, vaginal wetness and a full head of non-greying hair up until the age of like three hundred or something - cannot cure.

3 You didn't see the edge when you went to space and caught the alien cancer because you went straight up from the Earth into the sky and you were facing forwards, so you couldn't look over your shoulder until you were too far away to even see the Earth at all.

4 A broken heart will always be fatal: even when we live amongst sentient robots and sentient animals and sentient aliens, love will still have the power to kill a creature dead; in the late 21st century the organisation that arises out of the UN to deal with space (like in Star Trek) will designate a life form as anything with the capacity to love. This will help with the propaganda drive to make people feel no remorse for slaughtering and eating aliens and also for assuaging guilt about the like proper fucking climate apocalypse that will have happened here on Earth. How do you prove a creature can love, you might ask, and this is the topic that will overwhelm most political - not philosophical - discussion in the second half of this current century, when it will become apparent that we need to stop feeling bad for making things go extinct. Have you ever felt like a stone could love? No. What about a flower? No. A mouse? No. A snake? Definitely not. A dog? Yes. A cat? Yes. A dolphin? Yes, but there is no way any water-dwelling creatures will survive once all plant life has been destroyed and thus water is no longer oxygenated. We would have recognised dolphins as alive, yes, had they not already been dead.

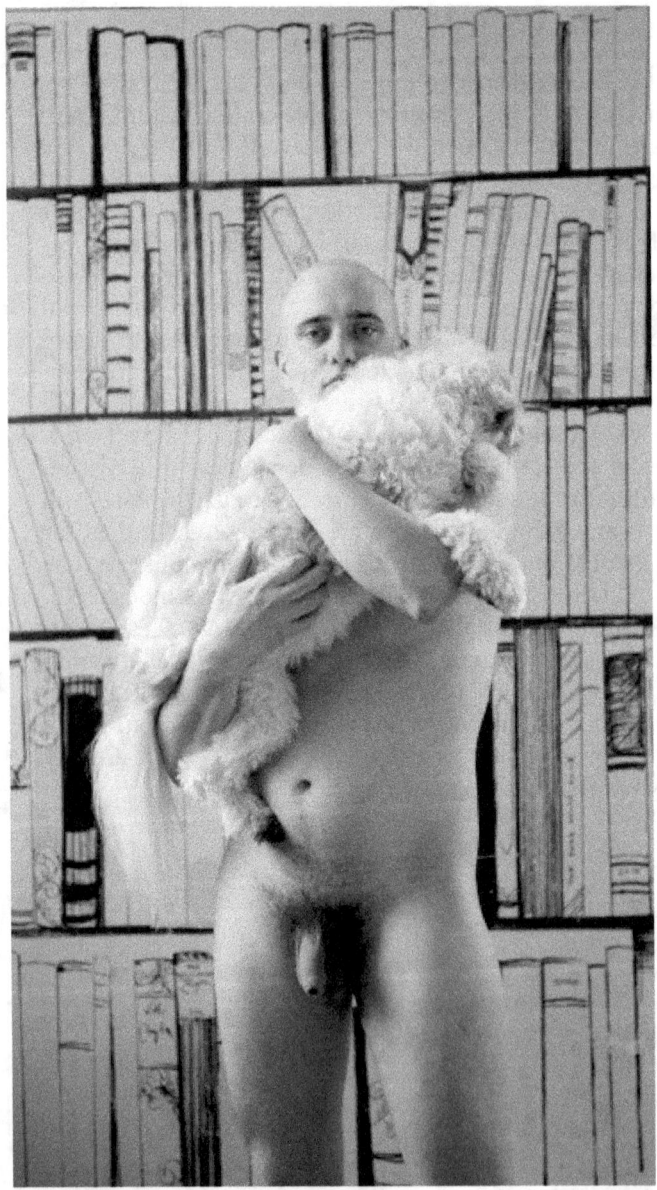

If you squint
And have a little faith
"Flat earth"
Is nearly an anagram of
"Truth Learned".

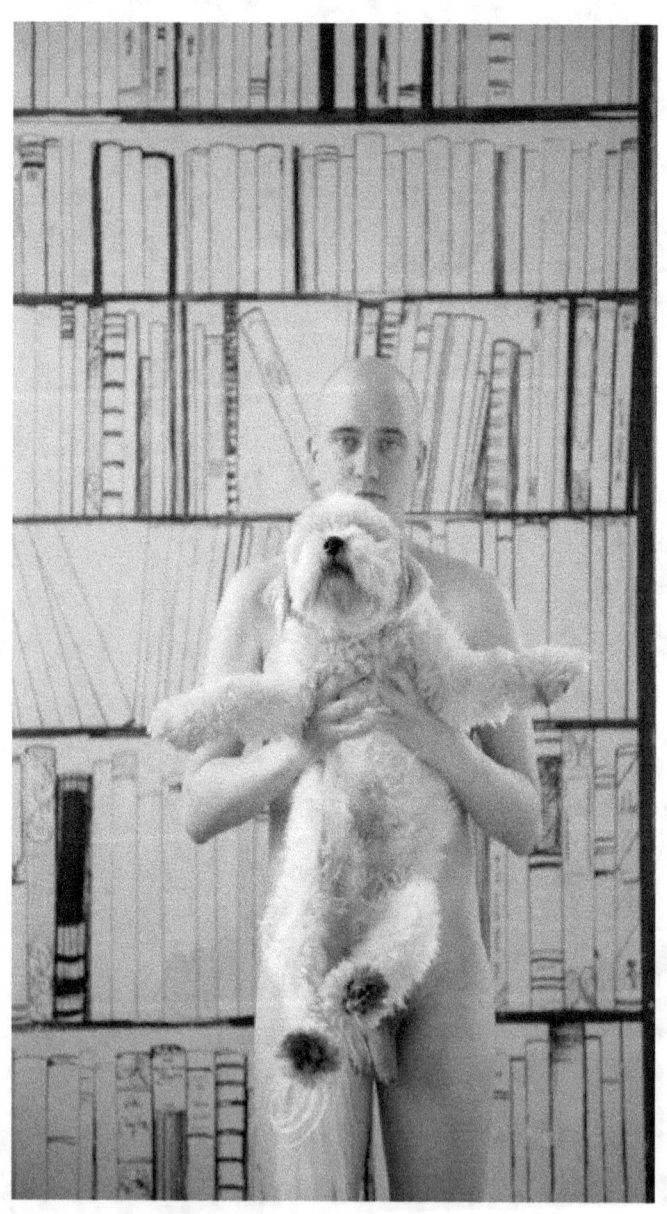

IT'S FLAT

The Conversation (Between two Flat Earth Poets)

SMH: Good afternoon, Sean Preston.

SP: Good afternoon, Scott [Manley] Hadley.

SMH: Thank you.

SP: Thank me for having you.

SMH: Thank you for having me.

SP: Yeah.

SMH: Sean, when did you first become a "Flat Earther", and is that the term you use to describe yourself?

SP: It's a term I would have used at first, but I've come to think of myself as a Flat Realist. Real Life Flatter. R Flat. I like R Flat at the moment.

SMH: That's not a term I'm familiar with. Can you explain?

SP: R Flat's my thing, it's just me. I noticed there are several splinter groups [of Flat Earth Truthers] so I thought maybe I should have my own thing completely, just go it alone, go rogue. That's why I developed R Flat. I always had somewhat of an interest in the world of hip-hop.

SMH: [nods, supportive and apprehensive]

SP: It's a rap name.

SMH: It's a rap name? [pause] I feel hip-hop is the musical genre that has the most overlap with the flat earth community. Why do you think that is?

SP: Truth. 100% truth. Cuz that's what we're doing all the time in **the world of hip-hop** and **the world of flat earth,** we're telling the truth. We're telling people things they don't wanna hear, but things they need to hear. Hip-hop and Flat Earth is talking real. It's talking flat.

SMH: Sometimes people do wanna hear the truth.

SP: Yeah. But I think those people - people like us - we're the minority. We are a minority group. Flat Earthers are a minority group. We're growing all the time, all the time, we both know that, but right now **we are a minority group.**

SMH: And how does that make you feel, being outside of the mainstream majority?

SP: I always felt this way, like I was different. You hear this a lot from other talented people, that they were bullied in school.

SMH: Like who?

SP: Eminem.

SMH: What?

SP: Eminem. Slim Shady.

SMH: Oh, I thought you meant the chocolates. American smarties.

SP: No. But to get back to…. I saw a documentary on a website called Nextflix.

SMH: What's Nextflix? Is it like YouTube?

SP: Yes, only Nextflix make videos themselves. And on Nextflix there's a full length film and it's called *Behind the Curve*.

SMH: Is it the only film on Nextflix?

SP: They have several, I think, but the only one I've watched in full is the flat earth documentary. It's called *Behind The Curve* and the title is referring to the curve of the earth-

SMH: [interrupts] what curve??? what curve of the earth?

SP: Yeah, right. What [the documentary] is doing is saying you should go "behind the curve", yeah, but the funny thing is you **can't go behind the curve** and that is what the documentary is about. I saw it and then… [shakes head, smiling] My whole life I knew I was different but at the same time I didn't really understand or **want to un-**

derstand "conspiracy theories," as they're known. I know that's a dirty word in the [Flat Earth] community, but I didn't feel like I was part of that community because I didn't know you could be special and talented and be in it, but then when I watched the documentary I realised I did belong. I saw the earth for what it is: flat.

SMH: [condescending] Can I pull you up on a couple of things you said there?

SP: [nervously, puts on sunglasses] Yeh.

SMH: When you dismiss the term "conspiracy theory" you are…. [trails off] Yes, "flat earth" is a **theory that involves a conspiracy. Technically**, it is a theory, as are all ideas. It is a theory that involves a conspiracy. So it **is** a conspiracy theory. [long pause] Yes?

SP: Can you repeat the question, sir?

SMH: I gave an opinion and then at the end I said "Yes?"

SP: Can you repeat the opinion, sir?

SMH: Just because-

SP: No bullshit.

SMH: Just because a theory **contains a conspiracy** and it **is** a conspiracy theory it isn't a "conspiracy theory". Nhm?

SP: Which one is a theory?

SMH: Everything is a theory. "Your name is Sean" is a theory.

SP: No, it's not Sean, it's R Flat.

SMH: Is that your movement or your name?

SP: I am R Flat.

SMH: Do you want that to be your name on the book?

SP: Naaa.

SMH: We need to be consistent across marketing. You are Sean Preston.

SP: You are Scott Manley Hadley.

SMH: What I wanted to get you to talk about in more detail-

SP: Go on, cut the bullshit.

SMH: I'm asking questions, there's no bullshit to cut here except in your diet [laughs]. How's that going by the way?

SP: It works for me. It's been beef 27 straight days now. It works for R Flat.

SMH: No, we're not using that name.

SP: [broken-hearted] It works for Sean Preston.

SMH: Works for Sean Preston, good. So, cutting the bullshit; actually I don't want to say "cutting the bullshit", that's a disgusting image. Have you ever sliced into bovine faeces?

SP: Some of the beef has been kinda questionable in that way because it comes vacuum-packed and [name redacted following legal action] could swear that some of it was the cow poo but I call bullshit on that. Cuz that's what you gotta do: you see something… it doesn't smell right, it doesn't look right, cut the bullshit. It's not like *Behind the Curve*, it's not literal, it's a metaphor.

SMH: I'd also at this stage like to point out to readers that the [name redacted following legal action] who Sean just mentioned is his wife: yes, he's married.

SP: [proudly] I'm a married man.

SMH: There's a really offensive stereotype in the mainstream media about **people like Sean** with outsider opinions and outsider hairstyles, that they aren't able to function on a basic socio-romantic or sexual setting, but Sean does indeed have a wife. None of us in the [Flat Earth] community have met her, but Sean assures me and the other fellas he has a wife.

SP: There is a [name redacted following legal action].

THE EARTH

SMH: She's just always out when we FaceTime, isn't she? [laughs]

SP: Cut the bullshit, there's a [name redacted following legal action], there's a Mrs [name redacted following legal action]. We did the… we went to a romantic wedding where we were the people getting married.

SMH: Marriage, like the horizon, is a beautiful thing.

SP: She said, 'I take you, R Flat', she said 'I take you Sean Preston, author, Sean Preston, I take you,' and I said 'yeah I take you too, [name redacted following legal action].'

SMH: In flat earth and in round, she said?

SP: Yeh.

SMH: And you said, woah woah woah, only in Flat Earth. [laughs]

SP: Do you wanna know something that's fucking cool? [brandishes ring] I found out the other day: this is a wedding ring that I got on my wedding day. Check it out, white gold, motherfucker. It looks like a sphere, right? [Holds it like a circle] However [drops ring] fuck fuck fuck if you look at it like this it's a line. [holds ring on side] if you alter your perception just slightly, move your eyes or your screen or just the ring, it's flat. It

doesn't have to be round. Depends on how you're looking at it, depends on perspective, bro, a little thing called perspective.

SMH: OK, Sean, I want you to cut the bullshit.

SP: Thank you.

SMH: Why do people believe the Earth is not flat? Play devil's advocate for a minute and try and convince me that the Earth is not flat.

SP: You want me to dance with the devil?

SMH: I want you to advocate with the devil.

SP: So I think they think it's a globe because when they enter this world what do they see when they go to school when they are five years of age? They see a globe, they see an atlas, baby, they see one of those [solar system mobiles] and inside that is a globe and she's just spinning and do you know what she's spinning? She's spinning yarns, motherfucker, she's spinning lies.

SMH: Is she spinning yarns or spinning lies?

SP: She's weaving a tangled web.

SMH: Is she a spider?

THE EARTH

SP: She's tricksy, alright.

SMH: Spiders are tricksy. Did you know that spiders make milk?

SP: [lies] Yes.

SMH: I read this recently and, as a mammal, I found it deeply offensive. Spiders are on my list of animals that I think should be destroyed.

SP: Did you know that tarantulas have milk? Did you know that, Mr PhD?

SMH: I don't have a PhD. Well, I do have a P.H.D: a pretty handsome dog.

SP: [laughs, impressed] Haha, you're a clever man. You are clever.

SMH: Yes, and I'm sure I could have a PhD if I had one. But spiders make milk, and me offended — as mammal.

SP: Is that a theory or is it a conspiracy?

SMH: It's not a conspiracy. It's a conspiracy that we were brought up being told that only mammals — i.e. the good animals — make milk. I think most animals that aren't mammals should be killed, starting off with insects except for bees because they're useful — apparently-

SP: They bring the honey.

SMH: They **literally** bring the honey. You never see a single beekeeper, do you? Never see a beekeeper who isn't married.

SP: I am married.

SMH: Would you ever keep bees?

SP: No. The bees are dying out. And I think that's because people aren't facing facts about flat earth theory, baby.

SMH: Honey is made from crushed bees. Are we eating too much honey?

SP: Another way of framing that question - and this is just me, what I do — R Flat - thinking outside the box, the sphere: are we not **crushing enough bees**?

SMH: How much honey do you eat… or drink? Outta the jar?

SP: I haven't had honey unto itself but I have, now and again, snacked on [cereal brand redacted as legal precaution].

SMH: And there's a honey in every nut loop?

SP: I believe so.

SMH: How many bees make one honey?

SP: Thirty seven.

SMH: When they make honey and they crush the bee, is all of that honey or do they

have to filter something out? Do the wings go into it?

SP: Everything. It's like grapes and wine. Everything [splash noise] and then you've got Ribena and then the old Ribena is the wine, and bees, they get crushed and that turns into honey Ribena and then the honey Ribena turns into the honey. That's just facts, man.

SMH: I'd like to ask you a more direct question. What do you think is up? I don't mean "What's up?" I mean what is up. What is up?

SP: OK, much tougher question, then. Up, I believe, this is me, this is R Flat, but other people share this belief. Number one, we got God, but he's being blocked out, baby, think about that. He's being blocked out because, what they did, I don't wanna say "they" because we all know who "they" is, there's a dome, right, and then we all live in the dome and it's like The Truman Show and then there's a moon and there's a sun and they're kinda like disco balls and they spin and they're just spinning and — I'm gonna go back to it, man, they're spinning lies, they're spinning yarn.

SMH: Clouds are yarn?

SP: I haven't really thought about the clouds.

SMH: OK. What is down? If we dig far

enough, we fall out?

SP: … …. What are the clouds?

SMH: Have you ever been on a plane?

SP: I have been on what I believed to be a plane when I was pre-truth™ but now I understand them to be simulation machines, not unlike we've seen in the movies, just the same, baby.

SMH: Which movies?

SP: Apollo 13, I think.

SMH: What's that about?

SP: Aeroplane goes to the moon, baby, and it can't get there.

SMH: Because it hits the roof? The top?

SP: The dome?

SMH: The dome, yes, like the Millennium Dome? A disaster, a disaster.

SP: It's a disaster movie.

SMH: I'd like to backtrack and ask: when you said "they", who is "they"?

SP: Yeah, we can't talk about this because of the… Amazon might be a bit [makes nervous facial gesture]. I think Amazon are the lizard people, too, but [shrugs]

SMH: I think that is one of your theories that is a [makes air quotes, laughing] "conspiracy theory'. Hahahahahaha. You know what I mean? What's at the edge of the world? For me, it's a wall of ice, it's GOT TO be a wall of ice. For you?

SP: Just educate me, man, I like this: educate me, educate me, Mr PhD.

SMH: I don't have a PhD.

SP: Well, think on that.

SMH: I'd love to, I mean I **would** have a PhD, but the universities are biased towards science, which is a methodology that favours falsifying evidence-based "proof" at the dismissal of exonerating personal evidence. I've been up large hills and even mountains, and I've been able to observe a) it's colder up there — if it was nearer "the sun", it would be hotter; b) You can't see a bending earth, the horizon stays the same. [SP belches in agreement] I've been near the sea, I've been near the ocean. I've looked with my eyes: you cannot see the curvature of the earth. The curvature of the earth is a bullshit thing and I'd —

SP: You gotta cut the bullshit.

SMH: I'd love to exist in a world where one could attend elite educational establishments and be **free to explore reality as we see and experience it,** but these insti-

tutions are far more interested in having their pockets stuffed by the lucre of the high finance petrochemicals heliocentric solar energy industries. Solar power is a myth. Have you ever seen anyone with a solar panel who looks like they regularly bathe? If solar panels were a truly effective and useful way of energy capture they would be on the houses of, of... we'd all have them. The sun does not make heat. The sun is a lightbulb, effectively, and not one of those old lightbulbs that does make heat, one of the newer lightbulbs that make a small amount of heat but mainly light. Like, you don't feel that heat unless you're gripping it with your hand by accident. There is a theory going round some of the chat rooms, some of the forums, that people gravitate towards flat earth and other theories rooted in conspiracy due to an absence of a sense of purpose in ones own life and the resurgence of conspiracy theories has come at a time when people like you and I - white, university-educated, sexually attractive men - are losing their aggressive hold on society, particularly culture and its finances. Men like you and I, feeling weak, are looking towards lies and finding faith in these ideas because we are unwilling to accept the reality of the world as it is. And every time I hear that [starts laughing] it just makes me crack up because the idea of... when I'm standing at the top of a tall building right on the rim and the fire fighters and whatever are all telling me to step back, to get away from the edge, "I'm just on the edge of the tall building, sweetheart, to look towards the horizon". Maybe if I'd got up

there and I'd seen a curve, maybe I would've jumped, but I trust myself, I trust my eyes, I trust my feelings and I trust the horizon. I trust you, Sean Preston. I trust you.

SP: You preach, professor Hadley. You preach. And we're listening.

SMH: Sean Preston, I'd like to ask more questions. You had never written any poetry before this project, is that correct?

SP: Nada.

SMH: What was it about your conversion to flat earth truth that led towards a decision to embrace what is, in my opinion, God's artform?

SP: [deep breaths] Poetry is not unlike rap, spoken word, spittin' lyrics. It felt like an organic vessel, a natural way for me to convey my opinions on flatism, flat earth theory, it was a way for me to cut through the bullshit of globalism.

SMH: Heliocentricism. Globalist heliocentricism. Heliocentric globalism? Heliocentric globalism. [nodding to self]

SP: Planetarianism.

SMH: Planetarianism? Isn't that the place where you can go and see the rockets?

SP: Sphere. Let's give them a little something. Sphere.

SMH: I peer.

SP: S. P. H. E. R. E? or

SMH: Peer?

SP: No, no, listen to the… S. F. E. A. R. S-fear? Poetry is breaking free of the fear, cutting right through it, it's saying "no, bullshit, not today my friend, God's listening and he sees everything." But it's from above the dome. But he sees everything unless the balls are turning at the wrong time, but he sees… he sees…

SMH: What poets do you read?

SP: I'm gonna surprise you here: 50 Cent.

SMH: Which of his works do you think is the most poignant? I'd say '21 Questions'. It shows a genuine vulnerability and an emotional need, which is refreshing to see in popular music, which is all too often concerned with just **making a great beat.**

SP: You know what I think? That 50 Cent is a flat earther right now. I think he sees the truth. I think he sees it for what it is. I think he looked at a 50 cent coin and he flipped it and he said wait a minute, perspective. Perspective, baby. Won't get a dollar out of me. What poets do you listen to, Mr Professor Doctor Hadley?

SMH: My favourite poet is, of course, Scott Manley Hadley. My second favourite poet, I'd have to say, is Sean Preston, but to be honest I only really read my own poems and I think that's… My advice, as a poet, is to do that, as to do anything else is to make your own work less pure, to water it down, to cheapen it, to — in other words — **make it less strong, less alpha.** Boys read, men write, as they say. Yes, I can understand the validity in reading while you're **learning** a language, but once you've learnt a language, i.e. you're seven or eight earth years old, from that point onwards if you wish to write you should only read your own material, because otherwise you will find yourself overly influenced by the texts of others. I read *Bad Boy Poet* (Open Pen, 2018) by Scott Manley Hadley two or three times every day. And it's a wonderful read that improves with rereading. Every fifth or sixth read I notice something — usually a typo - that I'd never noticed before, and it's lovely to be able to experience myself both as a stranger and as a friend and also as a sort of lover. Yes, no, reading things you haven't written yourself is childish. It's immature.

SP: OK. I'm not childish because I don't read 50 Cent, 50 Cent sings to me. We are both the same.

SMH: I think there are more similarities between the two of us than there are differences between two things that are more different than we are similar.

[long pause]

I have some more questions, Sean. Why did you invite me to collaborate with you on this project. Why not just "go it alone"?

SP: Can I just say thank me for having you.

SMH: Thank you for having me.

SP: And to answer your question, I don't know when it came to me... Perhaps a dream, perhaps shortly after a dream in that sort of twilight spell when you've just woken up, bleary-eyed and you're pissing everywhere and I thought, 'Scott Manley Hadley has to be a flat earth truther. He has to have seen what I have seen.' I knew you, Scott, **but I didn't know you.** It wasn't until, bleary-eyed, I was pissing on the floor next to the toilet again that I thought, 'Scott Manley Hadley is the only person who's going to understand this, what I'm going through, my whole world caving in to make a flat surface...' And then I said to myself as I used my t-shirt to mop the bathroom floor, "He needs to see what I'm seeing" and I DMed you, Scott, saying: "Do you know about flat earthism, anti-planetarianism?" And you said, "Yes I do, Sean Preston." If you remember, you said, "The world is flat, brother." And that's when I knew that we would come together and build beautiful flat earth poetry together. Does that answer your question?

THE EARTH

SMH: Yes, that answers my question.

SP: Same question back at you, no bullshit now.

SMH: It's just something to do, isn't it? Passes the time.

[Pause]

SMH: A new question for you, which animals are flat earthers?

SP: Sharks. Same question to you.

SMH: Monkeys. Elephants. Rhinos, dolphins, pigs. Ummm… tarantula.

SP: I think [simultaneous] all of them are.
SMH: [simultaneous] any spider that makes milk.

SMH: Scorpions. Not horses. Some cats, not all. That's it.

SP: Where do you stand on sharks?

SMH: If I disagreed with you I would have said something. There is absolutely no way I let any bullshit stand.

SP: OK, no bullshit.

SMH: The only bullshit I'm interested in is the bullshit that my cousin collects from the fields near his house that he uses to

power his moped. Doesn't go very fast, but boy is it stinky. Bullshit can be used as a fuel.

SP: He sounds like the kinda person who looks at things differently, outside of the box, baby.

SMH: When he made the moped, he was using his own… what's the right word… semen as the fuel, but then realised that he couldn't produce enough. And then he tried his own excrement. It was slightly better, but still he couldn't produce enough to get to the end of the road, let alone to, to, to–

SP: Kathmandu?

SMH: Well, he wasn't trying to get to Kathmandu, he was just tryna get into town to sign on. And eventually he realised that if he could get that fuel tank fuller, he could maybe do it. He had all of his family, all eight of the younger brothers and both of his parents and their – what's the right word – like an au pair but for

SP: Nanny?

SMH: I don't know what the word is that–

SP: [name redacted following legal action]?

SMH: Something like that. Executive assistant is maybe what they'd call it, if I was being kind. But he started collecting all of

their poo, too: a very open-minded family, too open-minded in my opinion. Even then it was enough for him to use it once a fortnight to go and get that cheque, but y'know once he had a bit of money in his pocket he wanted to ride around, see some of the guys from the chip shop where he used to hang out and then obviously he needs a little more power to the device and that was when he started adding animal matter to the vat. That's my story.

SP: It's a great story. I was watching a TV programme and in the TV programme a man made a joke about flat earth and this was also on a Nextflix film and he goes "boom mic drop, baby, gravity bitches" or something like that and I was just like, "OK, interesting that. Let's think about gravity for a second, shall we? So, doctor, the professor Isaac Newton, Mr PHD, he dropped his apple and what happened? The apple stayed still. Funny that. If it's a curved, curvatured, earth, then why didn't that apple roll all the way down and off the side? When he dropped the apple it went down and it stayed flat, flat on the surface. The same as when I hit the pool halls, and you know how I'm a pool shark, you know how R Flat rides at the pool houses. When I hit the cue balls, they don't go on forever and ever amen, you know. It's the same deal. They just stop after a while because it's flat. That's my story. That's my truth.

SMH: When you described yourself as a pool shark, I imagined you dressed as a shark in

a swimming pool. Which is much less dignified than the impression of yourself that you're actually presenting and I apologise for that.

SP: You are forgiven.

SMH: Can you swim?

SP: Yeah, I can. Of course I can.

SMH: How far?

SP: And also, the thing with the shark and the pool was a one time thing because it was Steven's stag do and everyone had to do sharks while he was the dolphin.

SMH: Steven had a stag do?

SP: [awkward pause] Yeah, I'm sorry, man.

SMH: I've got some more questions.

SP: Yeah, don't worry about Steven's thing.

SMH: Global warming, is it real?

SP: No.

SMH: OK. Are cats and dogs the same animal but cats are girls and dogs are boys?

SP: Yes, yes, that's really good. I'd never thought of that though. If you'd asked me that before you asked me that, I wouldn't have known, man.

SMH: Same question: cows and horses.

SP: No, man. Cows are already girls.

SMH: All fish are the same species, true or false? They're just the same.

SP: Is a shark a fish?

SMH: No, a shark is a shark, you've answered your own question there.

SP: All fish are the same, Hadley. All fish are the same.

SMH: OK. Is there such a thing as love?

SP: I believe in my heart.

SMH: Good. What happens to us if we die?

SP: This is great because we can go back to the question that you asked earlier and I didn't have the fucking guts to answer. Beneath this earth, no matter what they tell you, is Hell, baby. It's an inferno, yeah. Upside down, there's the inferno and its fires rage, my friend, and that's where you go if you don't tell the truth.

SMH: Where do you go if you do?

SP: If you do tell the truth?

SMH: Yes.

SP: To heaven.

SMH: Where's that?

SP: That might be the clouds, then? Maybe it's after the dome? Maybe you go to the ice wall? And then you climb up the ice to the top, around the dome?

SMH: What I like about you, Sean Preston, is that you're not afraid to reveal your ignorance. And that's very refreshing, because most alpha men won't do that. You don't mind looking the fool, and that takes balls. And not flat ones. Thank you.

SP: You're welcome.

SMH: It's admirable.

SP: Thank you.

SMH: We need to wrap this up, I have to prepare for the Epstein seance tonight. A couple more questions: Does Australia exist?

SP: So many sleepless nights.

SMH: A lot of that was the Adderall.

SP: Oh, man, does Australia exist? Long answer: no, it doesn't exist.

SMH: Short answer?

SP: Well, that's just no.

SMH: That's good. Have you ever been to America?

SP: Yes, I have, baby. US of A. Have you ever been to America?

SMH: Yes. You know what's good about it there? It's that they listen to people like you and I. People like you and I can be respected. Can go outside.

SP: Us truthers, we're embraced in the land of America, we're embraced, of course we are. There's no greater friend to truth than the land of the Eagles, baby.

SMH: Do you find your beliefs — sorry, not beliefs, your knowledge — has caused you to be treated differently from how you were treated before?

SP: Yes, mainly by [name redacted following legal action], my wife.

SMH: In what way? She's not not a flat earther!?

SP: She's undecided.

SMH: That could be worse. It's a journey we all have to make at our own pace in our own time.

SP: What I've found comforting in my time of need when dealing with [name redacted following legal action]'s perverse faith, her lack of faith, her doubt, is your po-

etry, man. It was your poetry that I read, your poetry that speaks about what to do when our loved ones do not believe. Must we forsake or must we teach? We must teach, and that's why we've written this book, to teach the world. You didn't say any of that directly in your poem I read, but I could pull it all out, man. And up here [points to head] it's internalised and I think about it every day and my heart it beats, my heart is a drummer, it beats beats beats with knowledge, with truth, with power, with God. Scott Manley Hadley, thank you. Thank me for having you.

SMH: Thank you for having me, Sean Preston.

fin

ABOUT THE PUBLISHER

Truther Press is a for-profit publisher specialising in books about alternative truths/[what sheeple refer to as] "conspiracy theories". It is run by Sean Preston and Scott Manley Hadley MA. Both publishers have been sexually active for over a decade and sexually competent for almost as long. The press is actively seeking manuscript submissions AND CASH DONATIONS via trutherpressbooks@gmail.com.